E. Munch

Great Modern Masters

Munch

General Editor: José María Faerna

Translated from the Spanish by Alberto Curotto

CAMEO/ABRAMS

HARRY N. ABRAMS, INC., PUBLISHERS

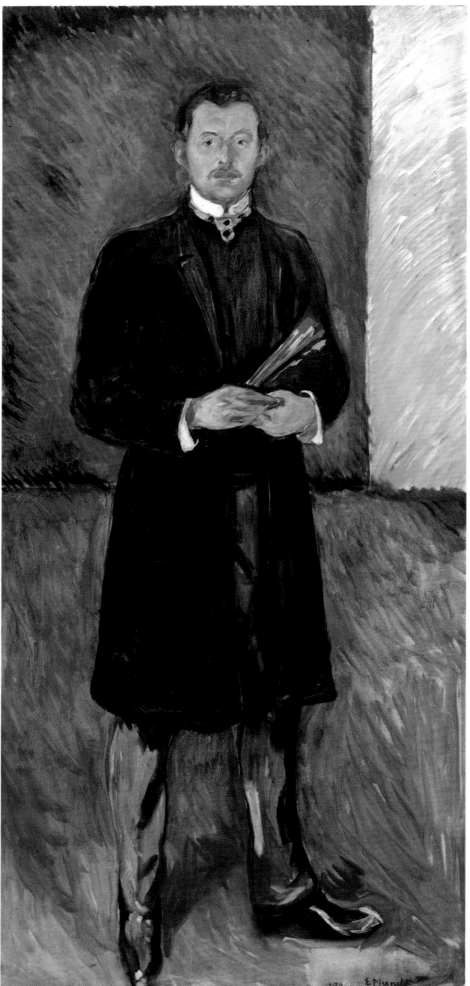

Self-Portrait with Brushes, *1904. Oil on canvas, 77½ × 36″ (197 × 91.5 cm). Munch-museet, Oslo*

Edvard Munch's Creative Angst

Some artists are inevitably associated with a specific vision of human existence. Just as Pierre-Auguste Renoir evokes a certain *joie de vivre* and Paul Gauguin the myth of the noble savage, Munch is usually regarded as the painter of modern anxiety, of the loneliness of humankind in modern cities, of failed love, of sickness, and of death. The somber, highly personal nature of his subject matter, compounded by the fact that, to this day, most of his work remains in Norway, has lent credence to the claim that Munch was a marginal artist who defies classification within the artistic framework of his age, and that only hindsight could reveal his kinship with major European artistic movements and trends. The painter's greatest merit, however, was his ability to address in a radically new idiom many of the issues that preoccupied nineteenth-century sensibilities. If one considers Romanticism and Expressionism as attitudes or outlooks rather than exclusively as movements or trends, one can legitimately say that Munch partook of both.

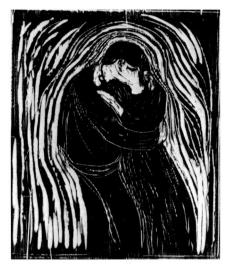

The Kiss, *1897–98. Munch realized several woodcuts, like this one, and one oil painting on this motif. In expressionistic fashion, the wavy lines around the lovers seem to propagate the echo of the kiss into infinity.*

Symbolism and Expressionism

Baudelaire perceptively observed that the keynote of Romanticism was neither a specific choice of themes nor a distinctive technique; rather, it was a unique manner of feeling. A new wave of opposition to objective and rational art took place in the last decades of the nineteenth century, in the aftermath of the Impressionist movement. The Symbolist painters, with whom Munch showed a certain affinity, experimented with a number of ideas, such as introducing into an artwork literary associations that would transcend the physical reality of the painted surface. Symbolists Gustave Moreau and Ferdinand Hodler turned, respectively, to hyperrealism and a meticulous ornamental style in order to evoke invisible worlds of their imagination. Munch's pictures, however, are expressions of his most crucial life experiences, and his artistic activity was for him an important means of gaining self-knowledge. In order to re-create his own inner world, the Norwegian painter ignored the Symbolists' path and opted for some of the innovations introduced by the earlier Post-Impressionist artists Gauguin, Émile Bernard, and Vincent Van Gogh, such as the manipulation of color to suggest ideas and feelings.

Paintings and Prints

From a technical point of view, Munch's major contributions—soon to be fully developed by the German Expressionists—are found in his graphic production. He was drawn to the graphic arts for two principal reasons. First, he wished to reach as many people as possible. Second, he was reluctant to part with his work, and by reproducing his paintings as prints, he was, so to speak, able to sell them and keep them, too. Munch was not possessive; rather, he wished to see all of his works collected together, since that was the only way, in his opinion, that his oeuvre could acquire its full meaning. Gifted with an inquisitive mind, Munch eagerly explored new possibilities within the mediums of lithography and etching. His fore-

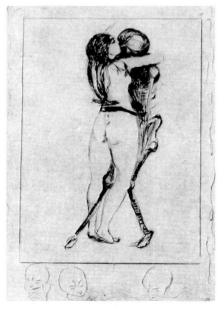

Death and the Maiden, *1894. Love and death are two recurrent themes in Munch's oeuvre. In this drypoint, the border is filled with spermatozoa-like images and human embryos, probably signifying the life force.*

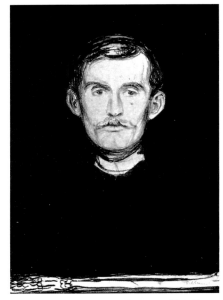

Self-Portrait with Skeleton Arm, *1895. The black background of this lithograph is reminiscent of prints by the Nabi artist Félix Vallotton, an almost exact contemporary of Munch's.*

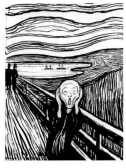

The Scream, *1895. A lithographic version of what is probably Munch's most famous painting (plate 11), which he realized in countless variations using different techniques and mediums.*

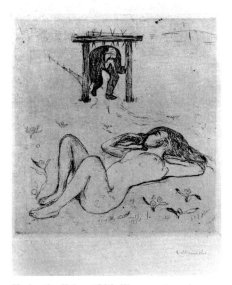

Under the Yoke, *1896. Woman viewed as both temptation and source of humiliation for man is yet another recurrent theme in Munch's work.*

most achievements, however, were in the field of xylography, or wood engraving, a technique that particularly appealed to him, inasmuch as it calls for considerable physical involvement, since wood offers resistance to the chisel's action. Munch's thirst for immediacy, somewhat incompatible with the laborious technique of color xylography, led him to devise a new, faster procedure that consisted in cutting the wood block so as to separate the different color areas, thereby creating a sort of jigsaw-puzzle effect. This stratagem not only enabled Munch to proceed more speedily, it also afforded him unsuspected sculptural possibilities.

Dark Angels

The dark, disquieting quality of Munch's work stemmed from his singular notion of existence, namely, the bitter view of someone who once declared that he had inherited two of humankind's most lethal foes, tuberculosis and insanity, and who stated, "Sickness, madness, and death are the dark angels that watched over my crib when I was born." Whereas his existential pessimism may have been largely determined by the adverse circumstances of his childhood—his mother's early death, the death of a sister, his father's melancholic disposition—the artist's conflicted view of love and women was a response to widespread social change. In this respect, one ought to regard as crucial his early involvement with a group of radical and unconventional young Norwegian intellectuals and artists who gathered around the anarchist Hans Jaeger and directed attacks against the straitlaced society of their time. The aspirations of those bohemians revolved around the notion of individual freedom, and notably around the idea of sexual liberation. For the most part, these young people came from wealthy upper-class families and were apparently rather indifferent to issues of social justice. Building on his personal experience of the contradictions of free love, Munch gave shape in his works of the 1890s to the sense of anxiety that the loss of solid referential values engendered in the modern consciousness: what Søren Kierkegaard called "the vertigo of freedom." The painter's dilemma had apparently reached an impasse: while he detested the traditional passivity and subservience of bourgeois women, he was at the same time terrified by the independent, uninhibited feminine ideal that the process of liberation was establishing—a personality type perfectly embodied by Dagny Juell Przybyszewska, his presumed lover (see plate 64).

Lack of Communication

Munch's dilemma had further crippling dimensions. Just as his speculations over the nature of sickness and death were an expression of grief by someone who loved life profoundly, his view of women was not as unfavorable as that of some of his famous contemporaries, such as Friedrich Wilhelm Nietzsche or August Strindberg. For Munch, woman was at once the mother he idealized, his beloved dead sister, and the object of a passionate attraction—a "leech with muscular thighs like a nutcracker." Paramount, however, was the artist's bitter awareness that a rewarding relation between human beings was impossible. Faced with this unpredictable and disquieting universe of human relations, Munch urgently felt the need to create a new artistic idiom, one untainted by bourgeois values or aesthetics. That radical goal soon attracted the attention of a whole new generation of artists, and it became a key to any understanding of twentieth-century art.

Edvard Munch/1863–1944

The correlation between life and work is unusually close in Munch's case. His personal experiences, in fact, color his entire artistic production. The son of an army physician, Munch was born in Løten (Norway) in 1863. He was not yet five when his mother died, a victim of tuberculosis. Thus began the artist's premature association with death, which would haunt him through his life, especially after the same disease, nine years later, killed his sister Sophie, two years his elder. His childhood unfolded in an environment that the painter himself once described as an "oppressive and gloomy" place.

Paris and Impressionism

After studying engineering for a year at the Polytechnical School in Christiania (Norway's capital, renamed Oslo in 1924), Munch decided to devote himself wholeheartedly to painting, and in 1880 he enrolled at the local art school. In the early years of his career, Munch was closely associated with Christiania's most radical thinkers, and especially with Hans Jaeger, the author of several tracts on anarchism. A trip in 1885 to Paris was of crucial importance to his artistic development. There he had the opportunity to attend the great Impressionist show held at the Durand-Ruel gallery, where he saw works by Claude Monet, Renoir, Edgar Degas, Camille Pissarro, and Georges Seurat, among many others. During the second half of the 1880s, some issues emerged in the artist's consciousness that became genuine obsessions during the remainder of his life. They made an entrance in such seminal works as the first versions of *Puberty* and *The Day After*. A most important painting of this period is *The Sick Child* (1885–86; plate 5), which reflects the painter's personal experience of his sister's death and already exhibits the characteristically desolate existential view that would characterize most of his later pictures.

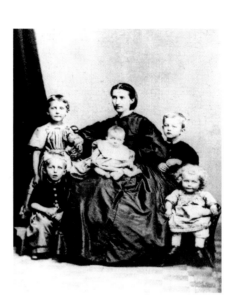

Munch's mother—surrounded by her children—is seated, probably in a photographer's studio. Edvard, standing next to her at right, was deeply scarred by the experience of her death, and later by the death of his sister Sophie (standing at left).

The German Secession Movement

In 1889 Munch's career underwent a momentous change. In October, the Norwegian government awarded him a scholarship that enabled him to live and study in Paris. After spending some time in the studio of Léon Bonnat, an academic painter, he settled in Saint-Cloud, on the outskirts of Paris, where he produced a number of Impressionist works. In the winter of 1891, dissatisfied with the constraints of the Impressionist style, Munch decided to steer his career in a radically new direction. This new turn was largely determined by his discovery of the works of such Post-Impressionist artists as James A. M. Whistler, Gauguin, and Van Gogh, and the Swiss painter of realistic mythological scenes Arnold Böcklin. In 1892, Munch participated in the exhibition of the Berliner Künstlerverein (Berlin Artists Union). In a country that had not yet assimilated the Impressionist experience, Munch's bold challenge was viewed as barely tolerable. The controversy around the Norwegian artist reached such magnitude as to force the closing of the show within a week of its opening. This decision alienated and antagonized many artists. Eventually, a group

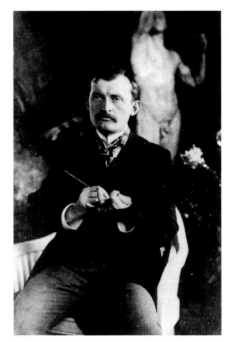

The artist—in a 1902 photograph—is seen seated in the garden of Max Linde's house in Lübeck, Germany. Linde, who became Munch's patron that year, commissioned a series of prints from Munch that are among the artist's finest.

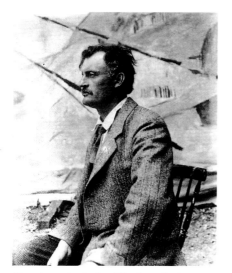

Munch posing before The Sun, *the large-format canvas on which he worked between 1909 and 1911, when this photograph was taken.*

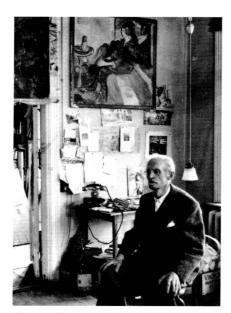

Munch, photographed in his studio on his eightieth birthday, is surrounded by his paintings, which he always regarded as a unit or, as he once said, "a symphony."

This wicker chair Munch represented in some of his most famous paintings (see, for example, plate 14).

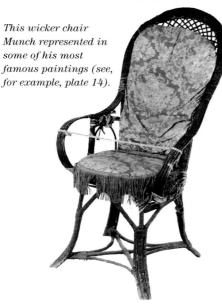

of Berlin painters led by Max Liebermann resigned their membership in the association and—as radical young artists in Munich had already done in a similar spirit of protest—they assumed the new collective name "Sezession" (Secession). As for Munch, the renown that came with his *succès de scandale* resulted in a number of exhibitions throughout Germany (where he lived for a while). In time, Munch exerted a significant and profound influence on Central European art, which would emerge with full force in the work of the German Expressionists, during the first two decades of the new century.

The "Frieze of Life"

Paris became once again a catalyst for Munch's development. In 1895, he traveled for the third time to the French capital. Here, the work of the Post-Impressionist geniuses made a profound impression on the Norwegian painter. The extremely simplified, silhouetted type of figure painted by Gauguin and Émile Bernard began to appear in Munch's work. Along with this decorative tendency, under the influence of Van Gogh, Munch began to alter and often to deform a motif in order to express a mood or a feeling. Most of these influences took shape in a significant cycle of paintings that Munch entitled the "Frieze of Life." Works in this series—such as *The Red Vine, Melancholy, The Voice* (plates 19, 20, and 26), and especially *The Scream* (plate 11)—expressed in a new idiom the artist's personal experience of love, sickness, death, and nature. Despite what may be suggested by the introverted quality of his art, the years between 1895 and 1908, when he experienced a nervous breakdown, were filled with frequent travels. The painter alternated long stays in Germany and Paris with summer vacations in his Norwegian house in Åsgårdstrand at Oslo Fjord.

Expressionism

At the turn of the century the artist, who had been painting with sinuous strokes around large, evenly colored areas, turned to a considerably more expressionistic manner, in which long, wide brushstrokes underscored an increasingly arbitrary use of color. Already palpable in *The Murderess* (1906; plate 36) and *The Death of Marat* (1907; plate 38), that shift became unmistakable after the artist's breakdown in 1908. In the fall of that year, Munch's nervous condition, aggravated by the effects of alcoholism, called for his confinement in a Copenhagen psychiatric hospital for eight full months. After his recovery, Munch returned to Norway, and a period began in which his production exhibited a renewed vitality. An excellent example of this new phase is afforded by the panels that decorate the main lecture hall of the University of Oslo (see plates 47 and 48). Munch's new optimism went hand in hand with increasing public recognition of his work. This process of acknowledgment culminated in 1912 with the Cologne Sonderbund exhibition—where Munch's importance was likened to that of Cézanne, Gauguin, and Van Gogh—and with a show in Berlin the following year. Munch spent the last two decades of his life in seclusion, at his farmhouse in Ekely, near Oslo, where he devoted himself with renewed intensity to painting. In January of 1944, in a Norway still under German military occupation, Edvard Munch died much the same way as he had lived his entire life: completely alone.

Plates

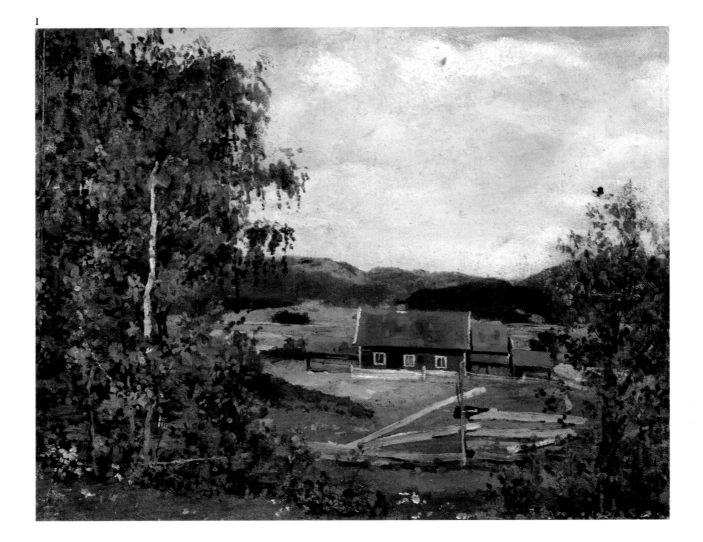

1

In Search of an Idiom

One of the traits that define the attitude of the young Munch is his search for modernity, his desire to break loose from the narrow confines of Christiania, a city that, in spite of a vocal population of young bohemians, was thoroughly pervaded by a stifling provincialism. To the young painter, the sophistication of Paris, which he first visited when he was twenty-one, must have had great appeal. In 1885, the French capital offered a mosaic of stimuli to the young artist, whose first works reflect the influence of the great protagonists of Impressionism—Renoir, Degas, Monet, and Pissarro. Gradually, though, in such paintings as *The Sick Child* or *Puberty* (plates 5 and 13) Munch began to show an interest in emotional and psychological themes that were thoroughly alien to the concerns of the Impressionists. During a visit to Paris in 1889, and after a period of experimentation with pointillism that bespeaks a familiarity with the work of Seurat and Paul Signac, Munch renounced that objective, impersonal orientation to painting, having reached the conclusion that "one should not paint interiors peopled by reading men and knitting women. One ought to deal instead with living human beings capable of breathing and feeling, suffering and loving." He thus articulated the foundations of his new painterly idiom.

1 Landscape: Maridalen near Oslo, *1881. Even before his first trip to Paris, where he would see at first hand works by the French Impressionist painters, Munch exhibited a fondness for landscapes. As is true of most of his later views, buildings and other human structures mingle here with the natural landscape features.*

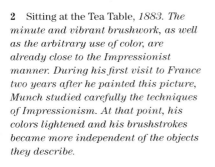

2 Sitting at the Tea Table, *1883. The
minute and vibrant brushwork, as well
as the arbitrary use of color, are
already close to the Impressionist
manner. During his first visit to France
two years after he painted this picture,
Munch studied carefully the techniques
of Impressionism. At that point, his
colors lightened and his brushstrokes
became more independent of the objects
they describe.*

3 Girl Kindling the Stove, *1883. Some
of Munch's earliest themes are interiors
where everyday activity is taking place.
Such themes were part of the
nineteenth-century tradition of
realism—the endeavor on the part of
artists and writers to depict the
ordinary and everyday, rather than
ideally beautiful or fanciful subjects.*

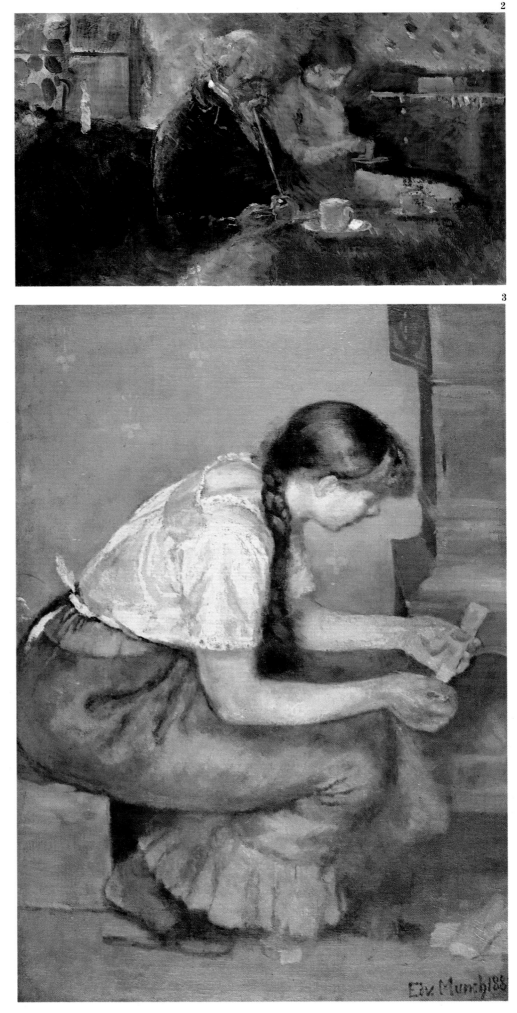

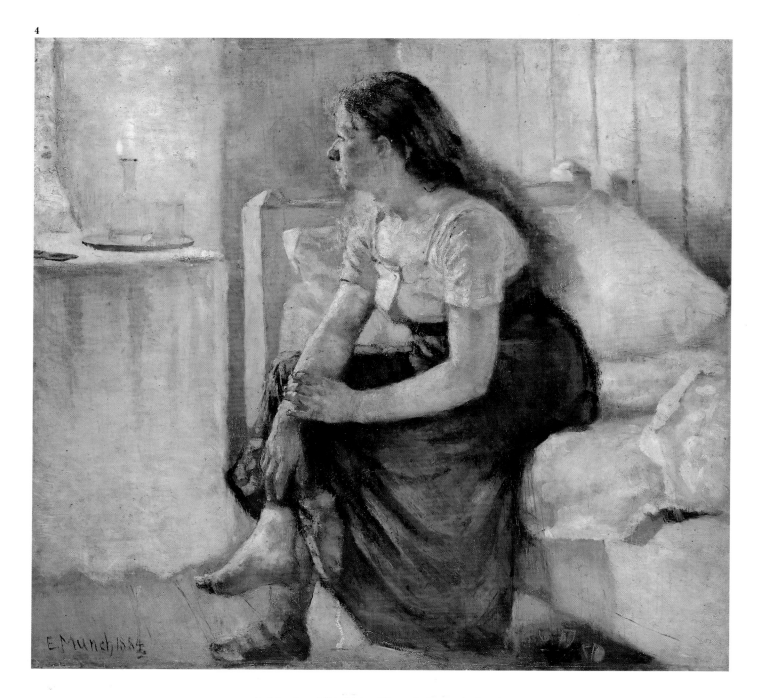

4 Morning, *1884. Light, filling a bedroom, bathes the body of a young woman and almost dissolves the glass objects on a table beside her. In later paintings, Munch would describe the effects of light on the human form with equal skill, but by then his outlook had darkened and shadows almost always prevail over the light.*

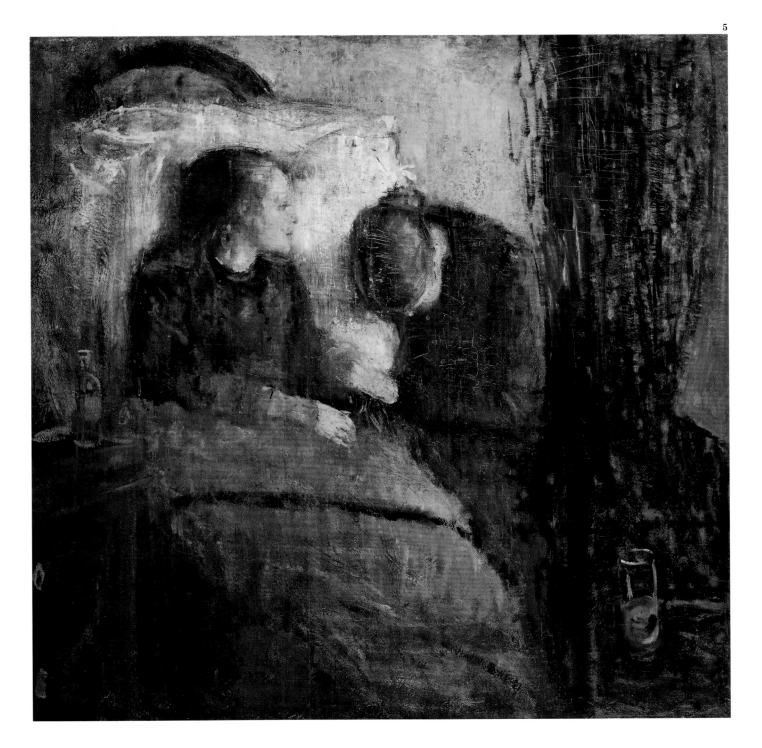

5 The Sick Child, *1885–86. In this first masterwork, Munch recollects the death of his sister Sophie nine years earlier, when the painter was thirteen years old. The artist himself would later write: "Over the course of that year, I made several changes to her, I scraped her, I let her dissolve into the soft paint and attempted over and over to recapture that first impression, the pale translucent complexion against the linen sheets, the quivering mouth, the shaky hands." The surface of the canvas—scratched and scrubbed with a cloth—bears the traces of that fierce struggle.*

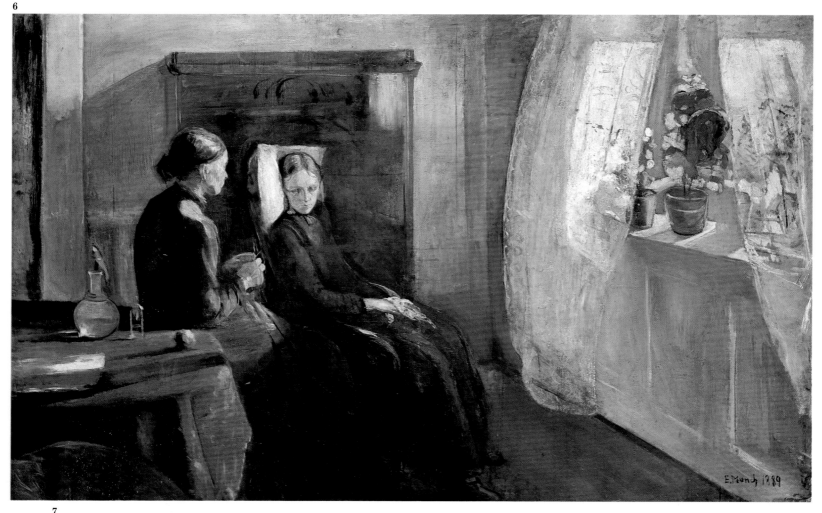

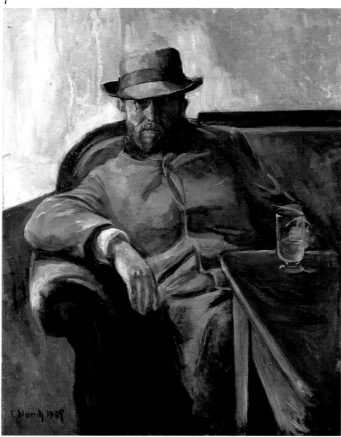

6 Spring, *1889. Four years after* The Sick Child *(plate 5) Munch returned to the theme of his sister Sophie's death. This time the rendition is much more conventional and of a blander emotionalism than before. This work is therefore much more in keeping with the prevailing taste of its age than the intense earlier version.*

7 Hans Jaeger, *1889. The mentor of Christiania's bohemian set, anarchistic leader, and prophet of free love is portrayed here as a despondent figure in front of a glass of liquor. Social ostracism on the part of Norway's middle class, not to mention several jail terms, seems to have left its mark on the radical ideologue.*

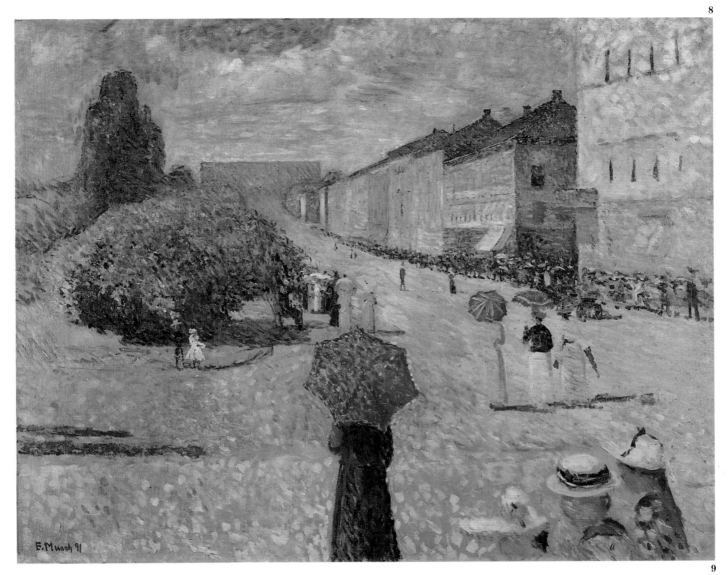

8 Spring Day on Karl Johan Street, *1890. Not long before the major shift that took place in his work in the winter of 1891, Munch experimented with some of the ideas that he had discovered in Paris. This painting clearly shows an interest in Seurat's pointillism.*

9 Night in Saint-Cloud, *1890. Munch has portrayed himself plunged in a state of desolation by the news of his father's death. The Romantic motif—a backlit figure looking through a window— is compounded with a symbolic allusion to death: the cross that the shadow of the window traces on the floor.*

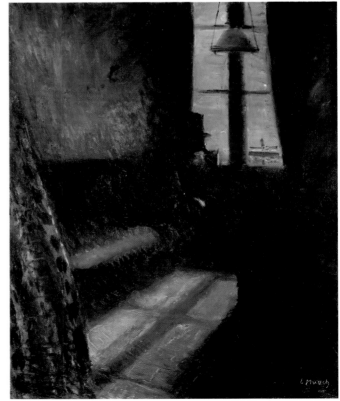

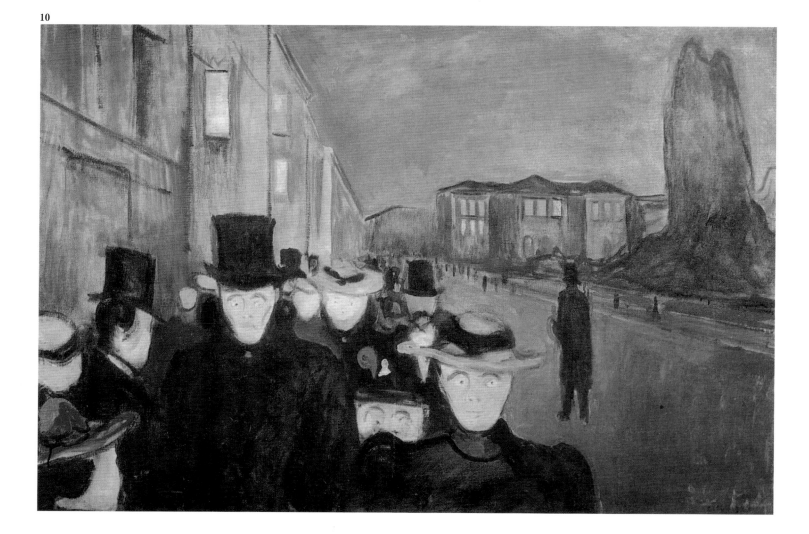

The Anatomy of the Soul

Throughout his career, Munch appears to have put into practice one of the edicts of his friend the poet Hans Jaeger: "Each one shall write his own life." That does not necessarily mean that all of Munch's works were of an autobiographical nature, but merely that they all stemmed from the necessity to reflect strictly personal concerns, sorrows, and fears. Munch's oeuvre was therefore fashioned out of two major elements: a constant reference to his real surroundings, on one hand, and, on the other, a subjectivism so profound as to modify perception. This type of approach, where the instinctual element dominates the rational one, makes clear Munch's kinship with the tradition of nineteenth-century Romantic art, and it had an impact on Central European Expressionism in the early decades of the twentieth century. More than anything else, as the painter himself avowed, it was a process of self-understanding. In his *Memoirs of an Insane Poet*, Munch wrote: "Just as in his drawings Leonardo explains anatomy, herewith I explain the anatomy of the soul . . . my task is the study of the soul, that is to say the study of my own self . . . in my art I have sought to explain my life and its meaning."

10 Evening on Karl Johan Street, *1892. A comparison of this painting with a picture of the same street that Munch had realized two years before (see plate 8) shows the profound change that took place in the artist's outlook and style at the end of the year 1891. The placid strollers of* Spring Day on Karl Johan Street *have turned into a procession of specters; the vibrant pointillist brushwork has thickened into strokes fraught with expressivity. The painting apparently depicts a personal experience of the artist: Munch had just run into his lover, who barely smiled at him and then went on her way.*

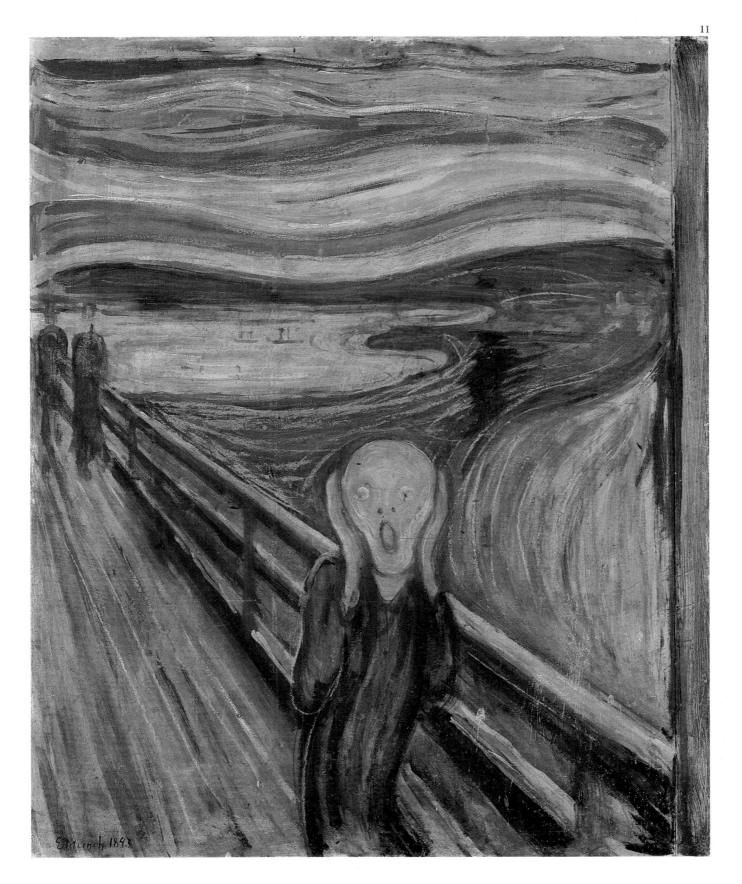

11 The Scream, *1893. Munch recounted the experience that led him to create this masterwork: "I was walking down the road with two friends when the sun set; suddenly, the sky turned as red as blood. I stopped and leaned against the fence, feeling unspeakably tired. Tongues of fire and blood stretched over the bluish black fjord. My friends went on walking, while I lagged behind, shivering with fear. Then I heard the enormous, infinite scream of nature."*

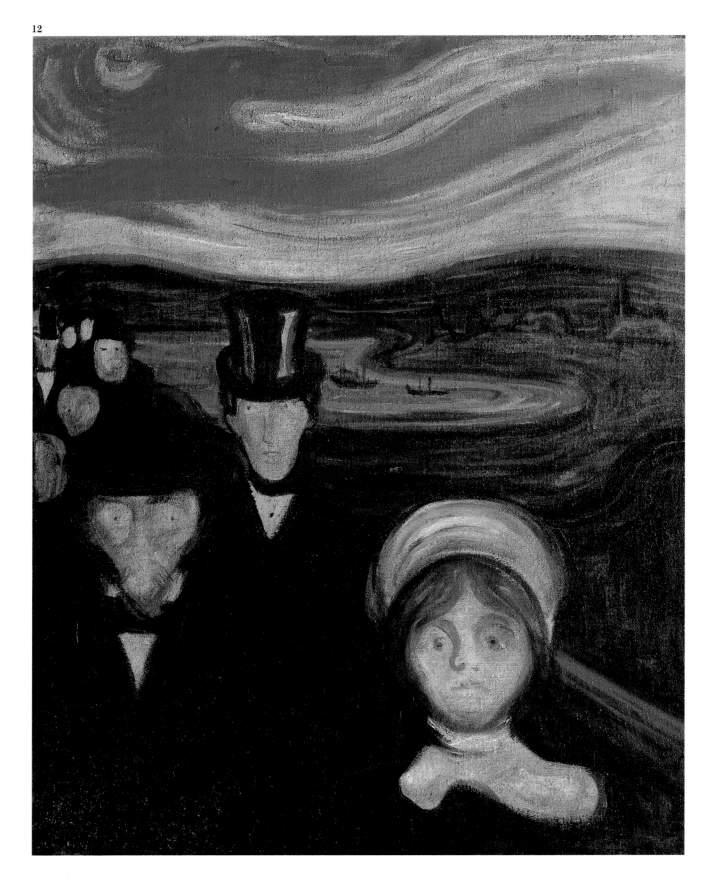

12 Angst, *1894. In this work, the painter developed further some of the expressive innovations of* The Scream *(plate 11). The background is the same—a readily identifiable place at Oslo Fjord—but the solitary figure has been replaced by a group of people resembling the crowd moving along Karl Johan Street (see plate 10). As in that painting, the high viewpoint pulls the figures toward the observer. The long and sinuous brushstrokes, reflecting the influence of Art Nouveau, create a highly charged effect.*

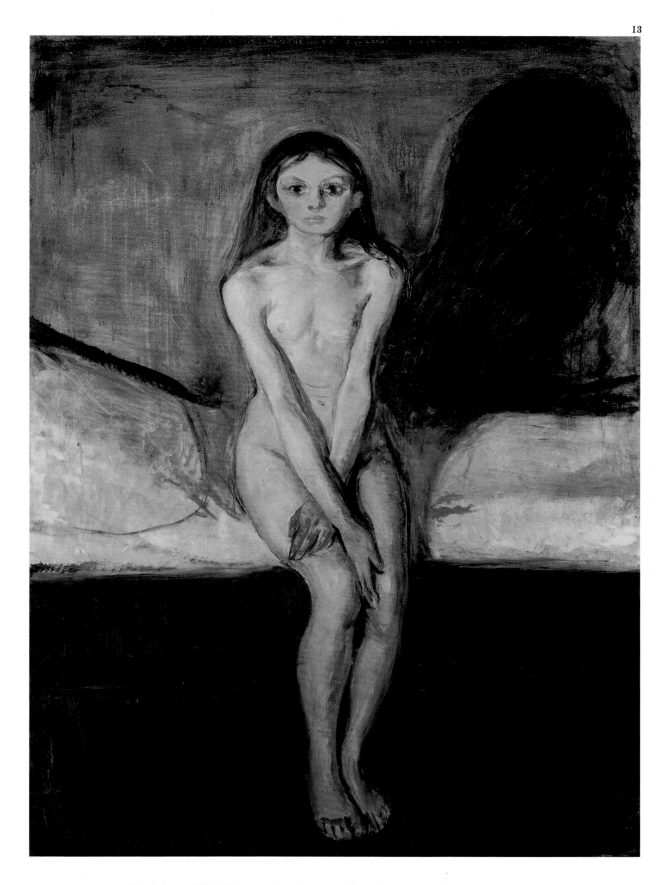

13 Puberty, *1894. This is the best-known version of a theme that Munch rendered repeatedly throughout his career, beginning in 1886 with a painting that was later destroyed in a fire. The artist has portrayed the natural changes in the girl's body as a traumatic experience. The black shadow may allude both to menstruation and to the girl's state of mind. Her hands conceal the source of her shame and fear.*

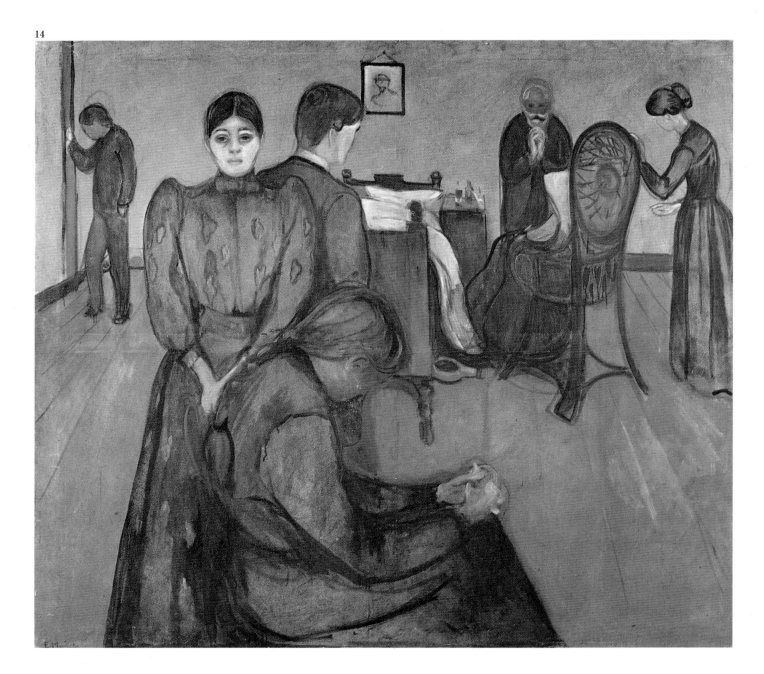

14 Death in the Sickroom, *1894–95. Munch returned to the theme of his sister's tragic end time after time. The title notwithstanding, the painter did not need to represent death in an explicit manner, for he pervades every corner of the room with its disquieting presence.*

15 The Dead Mother and the Child, *1897–99. Munch's autobiographical stamp is evident on works such as this, which represent the death of the member of a family. The scream of the little girl, emphasized by the shrill red of her dress, underscores the stillness of the mother's body, a hastily sketched figure that seems to be vanishing into the deathbed.*

16 Golgotha, *1900. This representation of the Crucifixion is one of the earliest pictures to show the changes in Munch's technique at the beginning of the new century. Large, uniform areas of color have been replaced by a vigorous and apparently careless brushwork, whose violent color contrasts emphasize the gestures and features of the depicted figures.*

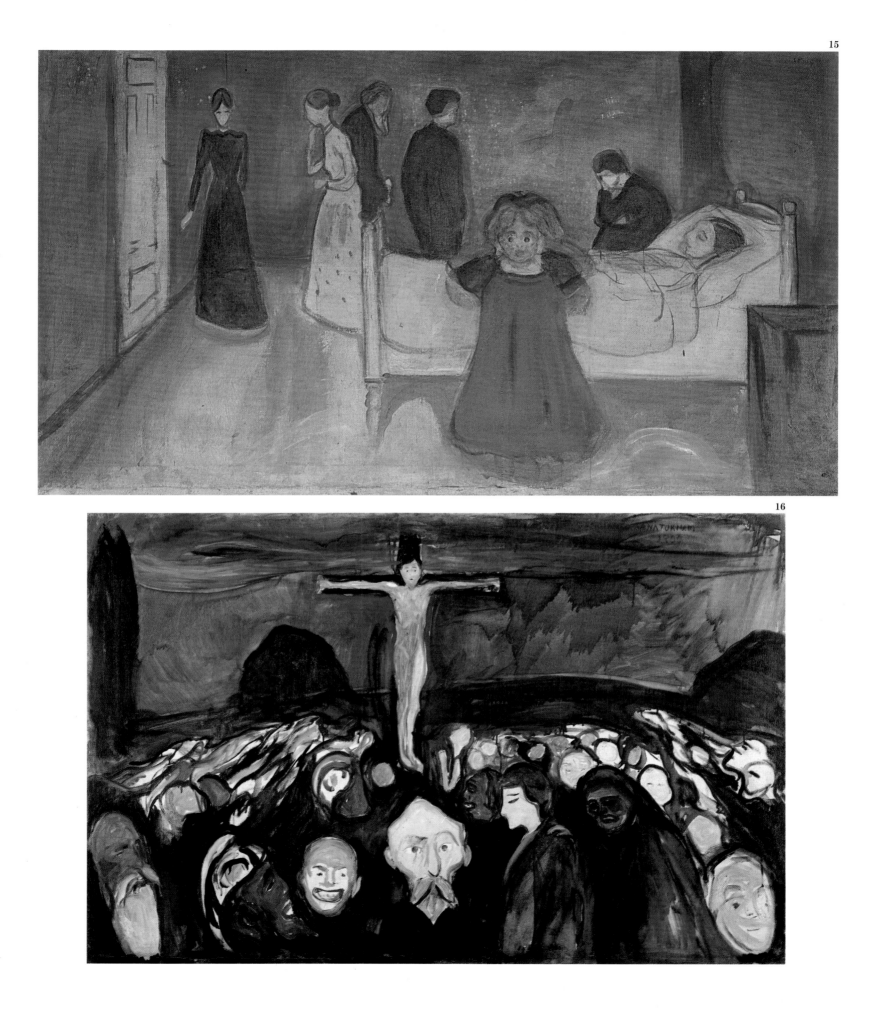

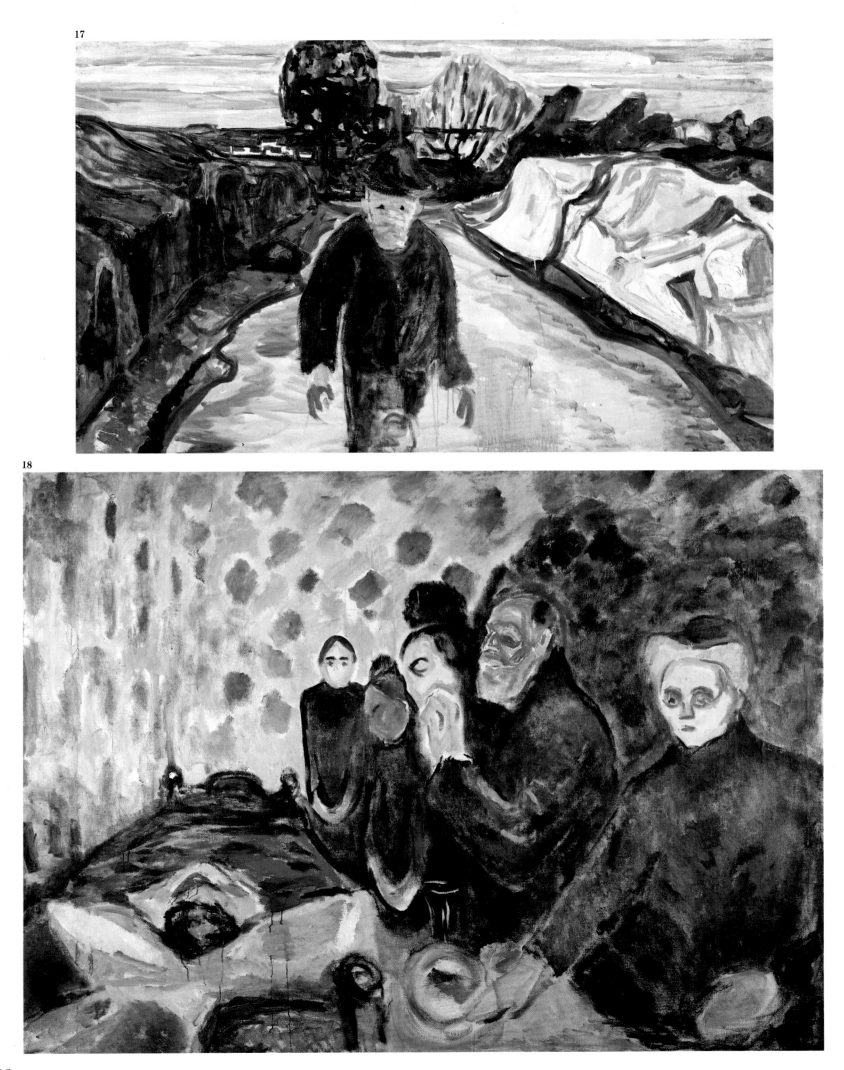

17 The Murderer, *1910. One of the most disturbing images of Munch's entire production is this sinister figure, whose features are erased. The nightmarish effect of his advance is reinforced by the use of exaggerated perspective.*

18 At the Deathbed (Fever), *c. 1915. In this painting, having become acquainted with the young German artists of the group called Die Brücke, Munch approached one of his most typical themes with renewed expressionist vigor. As in his other deathbed pictures, each figure appears to be an embodiment of death.*

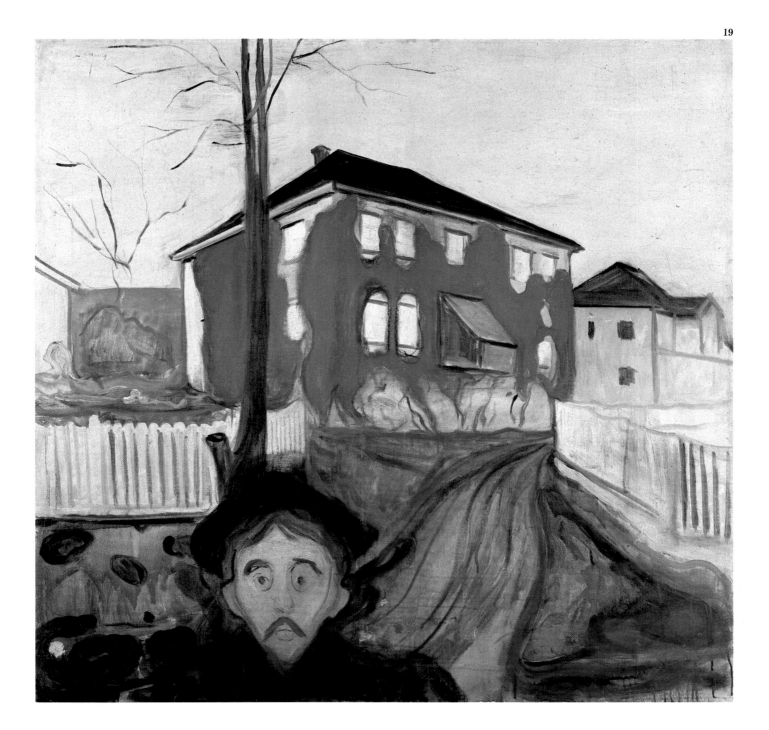

19 The Red Vine, *1898–1900. This is one of the final works of the cycle "Frieze of Life." Munch's frequent device of showing a cut-off figure advancing toward the viewer is here tinged with a new significance: the man's gaze is almost visionary, as he appears to possess the disturbing ability to see what is taking place behind his back.*

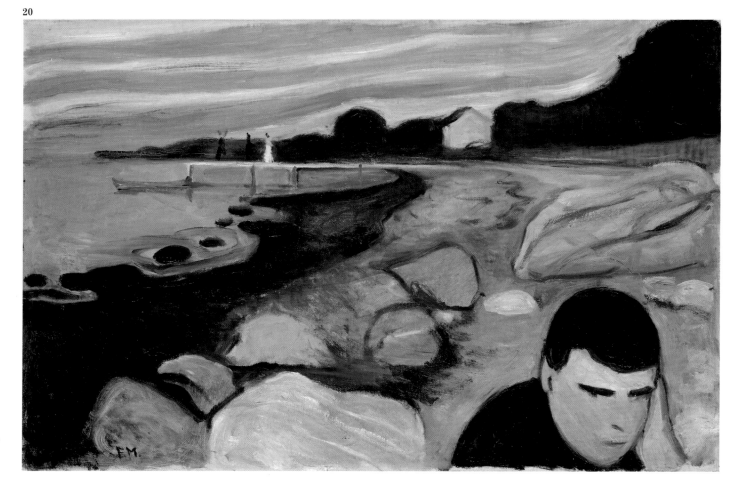

The Femme Fatale

The relation between the sexes was a central issue for late-nineteenth-century artists and writers. Almost exclusively men, they offered a hostile view of woman: stripped of her admirable and pleasant attributes, in many works of art and literature she became the embodiment of evil. The theme of the femme fatale, whose formidable charms eventually bring men to physical and moral ruin, was represented time and again: it was, after all, an age obsessed with the story of Salomé. Toward the sexual relationship, Munch's feelings were rather ambiguous, and they appear to have grown from some exceeding personal fear rather than the kind of misogyny that led Munch's friend the playwright August Strindberg to put on the same level his hatred of "microbes, bugs, and women." The Norwegian painter appears to have been fascinated by women's charm, by their ability to bear children, and by the haunting and disturbing mystery of the feminine nature. But his view of sexuality is bleak; hardly, if at all, he felt, did it bring happiness. Yet, he never seemed to blame women for that: its cause, he would say, lies in the very essence of things, a fateful mechanism that is inevitably bound to breed the wretchedness of the two lovers, and which neither of them can ever hope to escape.

20 Melancholy (Jappe at the Beach), 1892–93. This work is evidence of the radical shift in Munch's style at the conclusion of his experiments with pointillism. It is also the first painting in which he approached the theme of jealousy: the figure in the foreground (his friend Jappe Nilssen) expresses consternation upon discovering the infidelity of his lover, who is depicted in the background.

21 Separation, *1894. As in other works by Munch, the reflection of the moon on the water has an unmistakable phallic symbolism. The deterioration of the canvas reflects the artist's penchant for leaving his works exposed to the action of rain and snow.*

22 Ashes, *1894. The smoldering fire in the foreground activates a metaphor for the end of a love affair, which for Munch was always associated with feelings of guilt and frustration.*

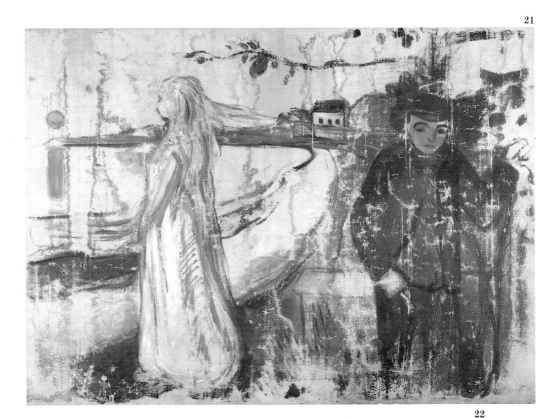

22

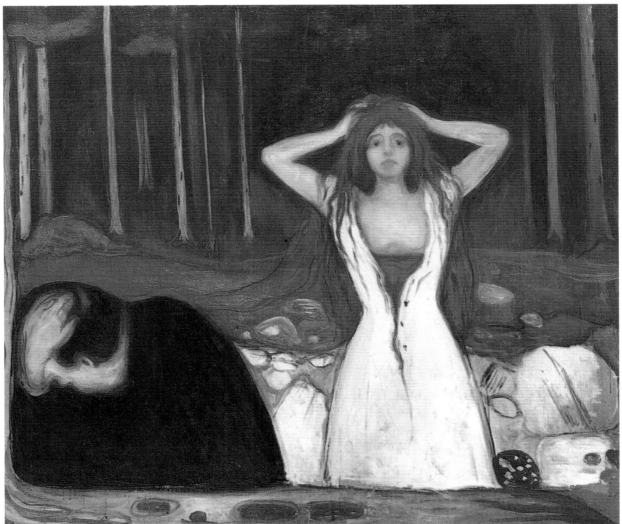

23

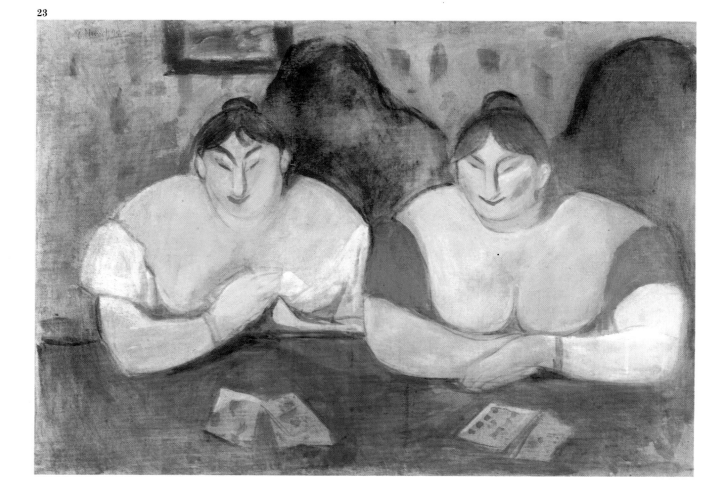

24

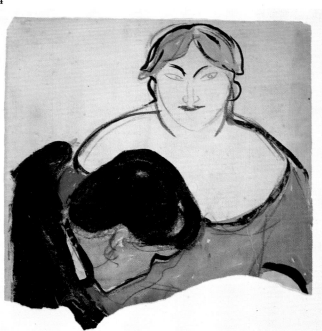

25

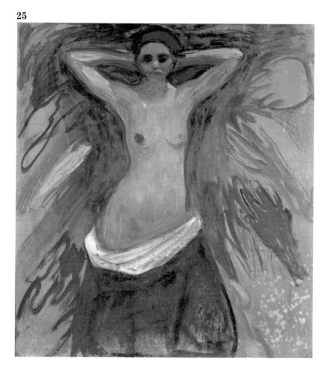

23 Rose and Amélie, *1893. These two prostitutes, with their blunt features and a certain animal quality, are the antithesis of the femme fatale. Lacking the power of seduction, they appear to be totally unthreatening.*

24 Young Man and Prostitute, *1893. In this painting, Munch represented the feelings of guilt engendered by hired sex. The woman's absolute indifference—which is also expressed in the features of the two prostitutes in the previous plate—contrasts sharply with the prostration of the young man who, gray with shame, is concealing his face.*

25 The Hands, *1893. The feverish current of desire engendered by the female body is expressed in this and many other works by Munch—here, strikingly, by a flock of colored, disembodied, and lustful hands reaching out in an unsuccessful attempt to touch a naked woman.*

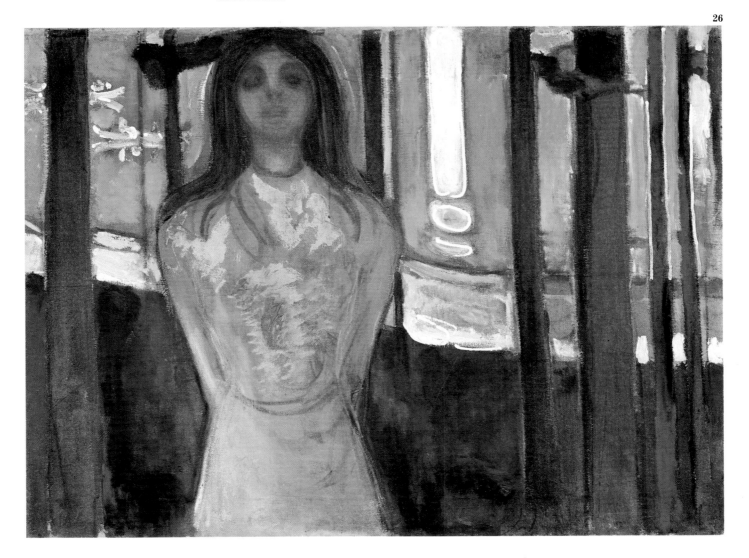

26 The Voice, *1893. In one of his writings, the artist described the experience that had suggested this painting: "A golden column quivered from top till bottom on the water surface, melting into its own gleam and dispersing through the waters. When our gazes meet, invisible hands weave fine threads from your big eyes to mine, thereby knotting our hearts together. . . . How pale you are in the moonlight, and how dark your eyes, so large as to cover the greater part of the skies."*

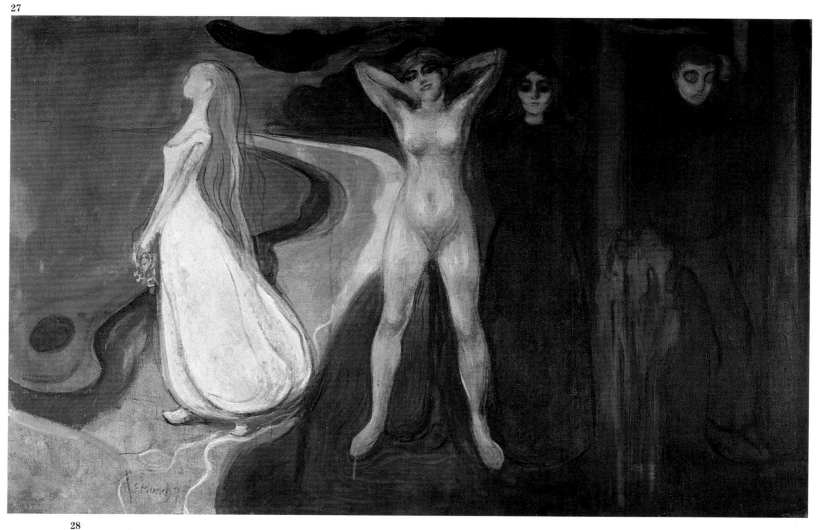

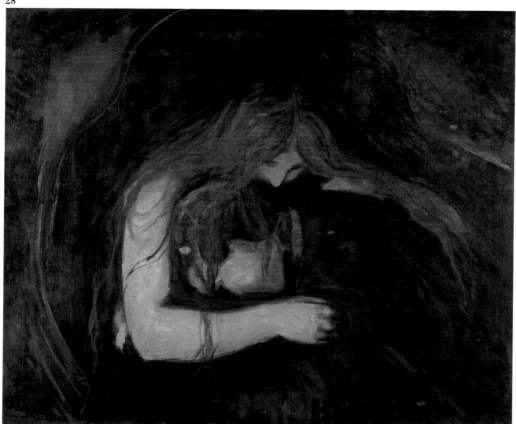

27 The Three Stages of Woman, *1894. The span of human life is often represented by artists as a human being (man or woman) in different stages of development and decline. In this painting, Munch shows, from left to right, woman as innocent young girl, then in full sexual maturity, and finally fading into old age. At far right, separated from the women by a barrier, is the figure of a man.*

28 Vampire, *1893–94. Munch described woman as a being who absorbs her lover's energy: "And he lay his head on her bosom: he felt the blood flowing through her veins and heard her heart beat. He buried his face in her lap, perceived two burning lips on his neck, felt an icy shudder and a staggering desire, and vigorously pressed her body against his."*

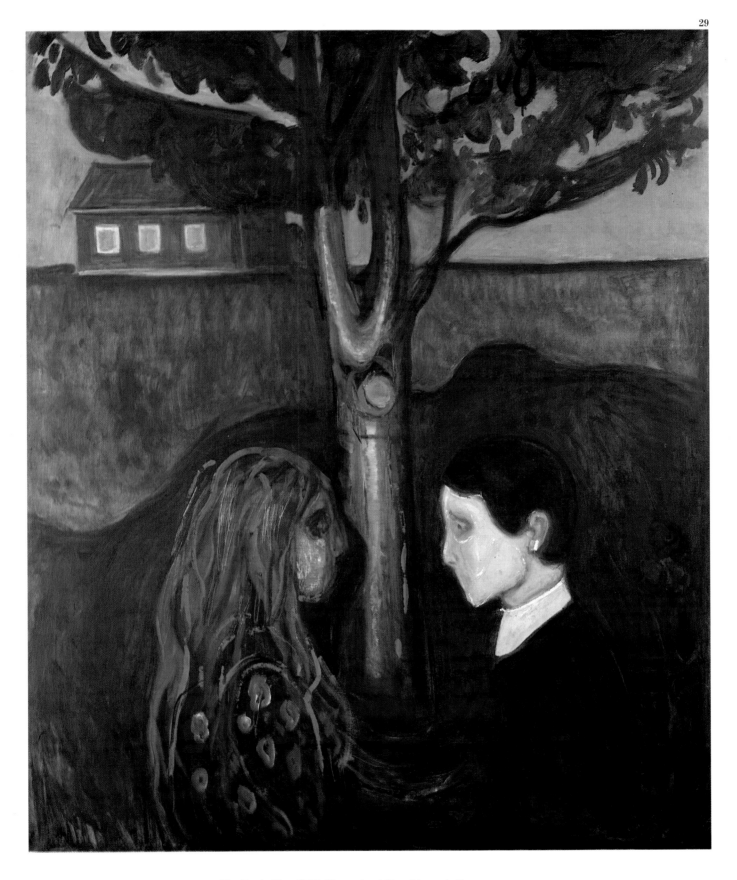

29 Eye to Eye, *1894. Throughout Munch's work, flowers symbolize the spiritual development that is attained through suffering. In this particular painting, the roses on the woman's dress suggest a dimension of life at odds with the promise of domesticity represented by the house, an environment that, according to the artist, was bound to prevent human creative potential from flourishing.*

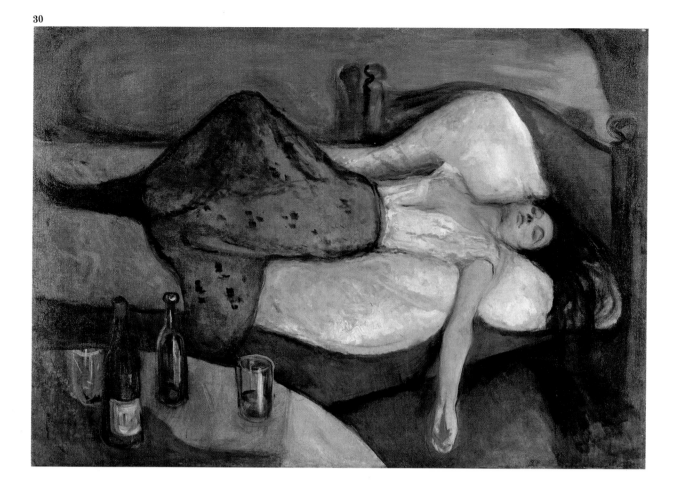

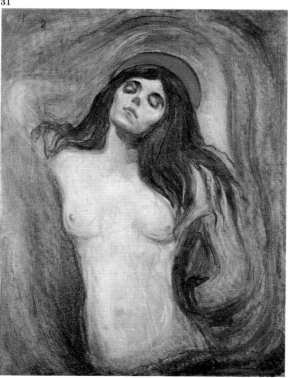

30 The Day After, *1894–95. This is a later version of a painting of 1886 that was destroyed in a fire. The theme of a woman in the grip of her own vices is a recurrent one in the art and literature of the second half of the nineteenth century.*

31 Madonna, *1894–95. This painting has also been entitled* Conception. *Munch himself described it in these words: "The pause during which the entire world halts in its orbit. Your face embodies all the beauty of the world. Your lips, as crimson as a ripe fruit, are half open as if to express pain. A corpse's smile. Here life and death shake hands. The chain that links thousands of past generations to the thousands to come has been meshed."*

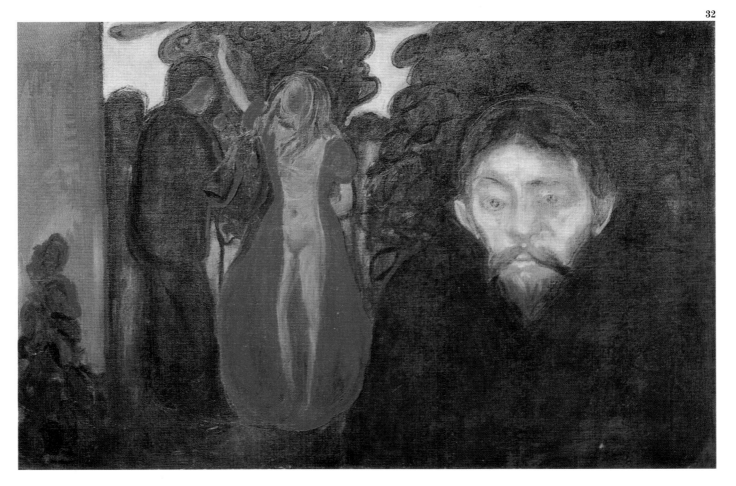

32, 33 Jealousy, *1895; Jealousy I, 1896. The painting (above) and the later lithograph (below) conceivably depict an episode in the artist's life. For a time, together with the playwright Strindberg, Munch used to visit the house of the poet Stanislaw Przybyszewski, with whose wife both men had fallen in love. "I cannot understand how my poor nerves could put up with it. I sat at the table and could not utter a single word. Strindberg went on talking. Then all of sudden I thought: 'Could it be that her husband is really not aware of anything? He will quite likely turn green first and then fly off in a rage.'"*

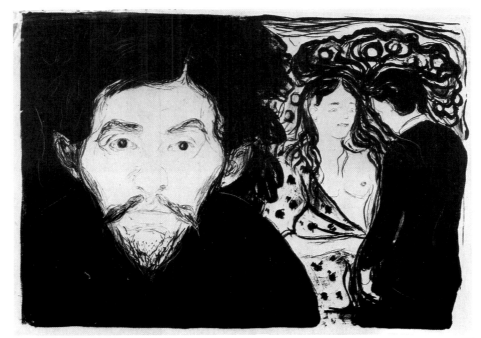

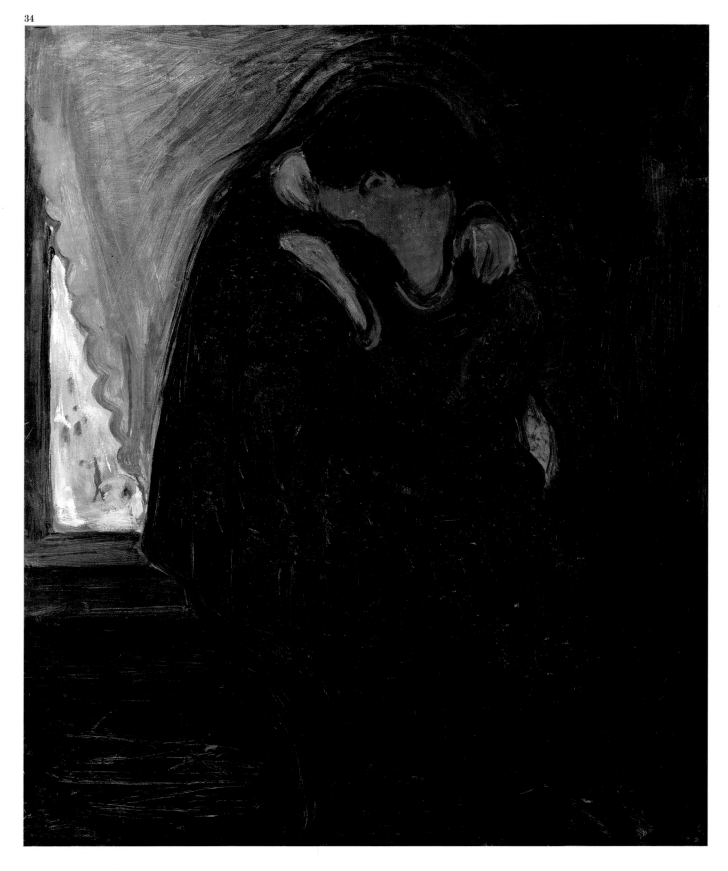

34 The Kiss, *1897. The intensity of the lovers' passion is made visible in the wavy aura that encircles their heads. In the many woodcuts that Munch made on this theme, grooves left by his chisel create the same effect.*

35 Metabolism, or The Transformation of Matter, *1899. In this very strange representation of the story of Adam and Eve, the tree, symbolizing the life cycle, feeds on decaying bones. Towering above its crown, and symbolizing modern urban life, is the skyline of the city of Christiania, identifiable by such landmarks as the castle of Akerhus and the Church of Our Savior.*

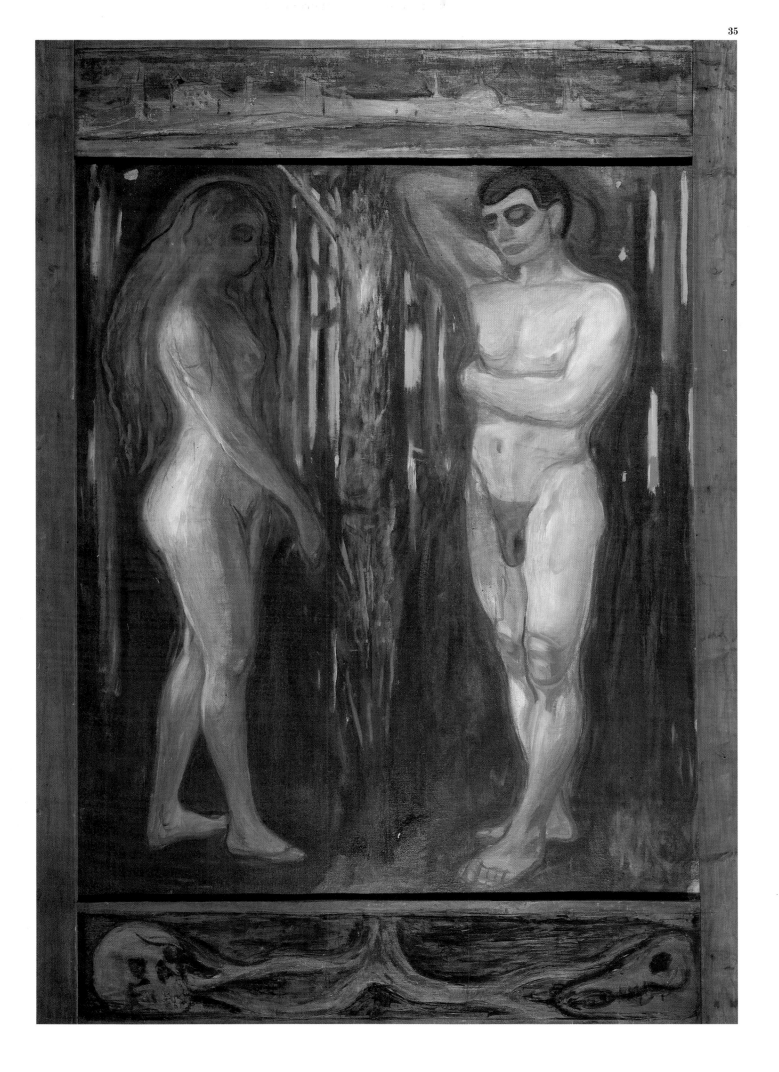

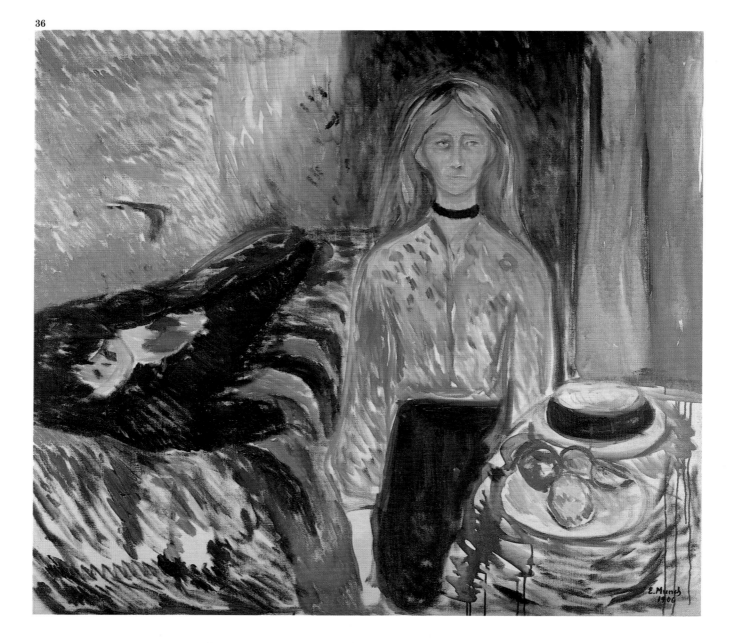

36, 38 The Murderess, *1906*; The Death of Marat, *1907. Two paintings on this theme attest to Munch's fascination with the murder of Jean Paul Marat, a hero of the French Revolution, by Charlotte Corday. In both paintings, Munch has chosen to show the moment when Corday, having committed her crime, reveals her desolation to the viewer. With violent strokes of arbitrary color, Munch deliberately distanced himself from the famous neoclassical painting of the dead Marat by Jacques-Louis David.*

37 The Dance of Life, *1899–1900. This work sums up many of the themes of the "Frieze of Life" cycle. On the left, a young maiden in virginal white raises her open arms toward a flower. On the right, an older woman with clasped hands looks on with a bitter expression. Between them, a woman in the prime of life ensnares in the train of her scarlet dress her dancing partner, who like the other dancers seems to be in the thrall of a force over which he has no control.*

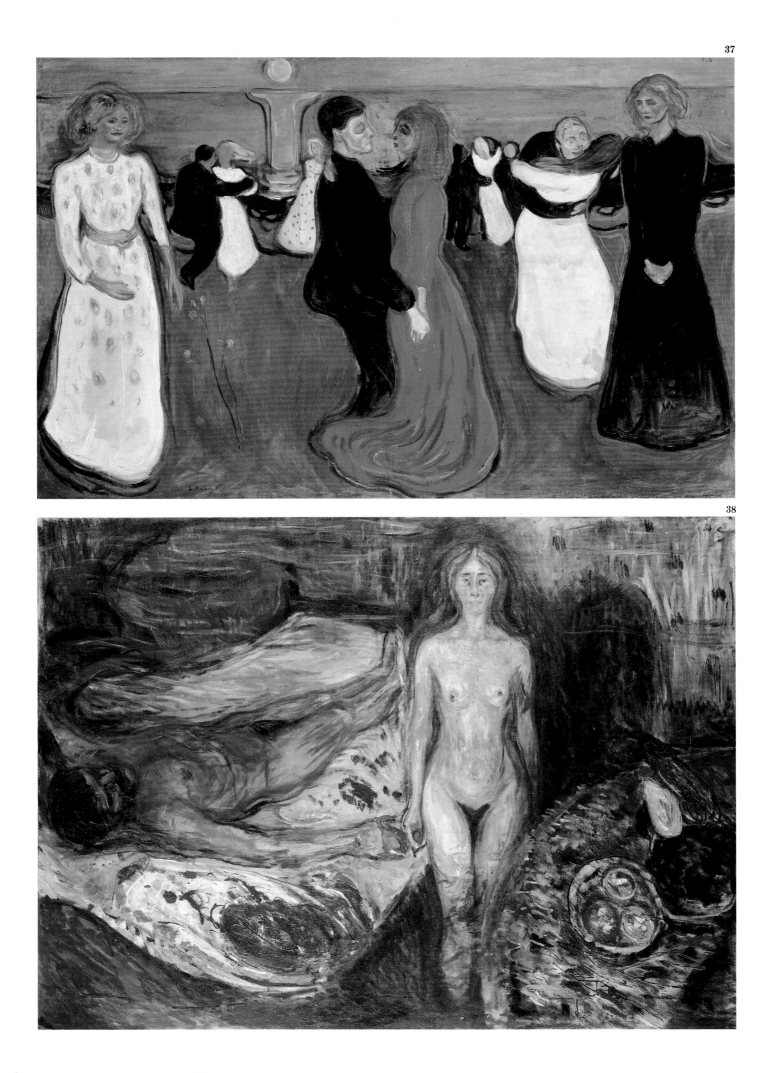

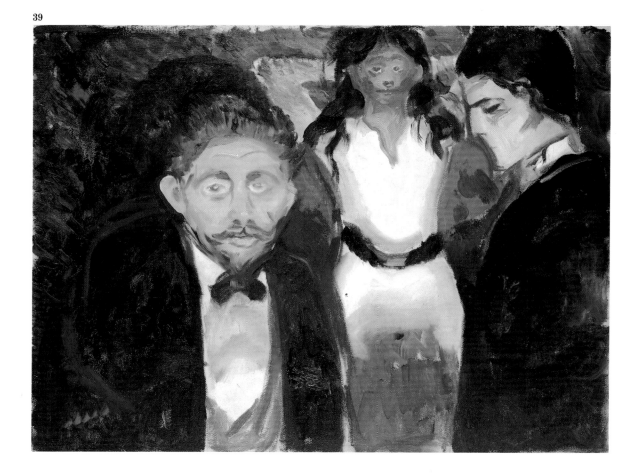

39, 40 Jealousy, *1907;* At the Whorehouse, *1907. These are two in a series of six paintings that Munch executed in the summer of 1907 and entitled "The Green Room." In both works, the use of color arbitrarily, for expressionistic purposes, is evident. The influence of Art Nouveau has disappeared.*

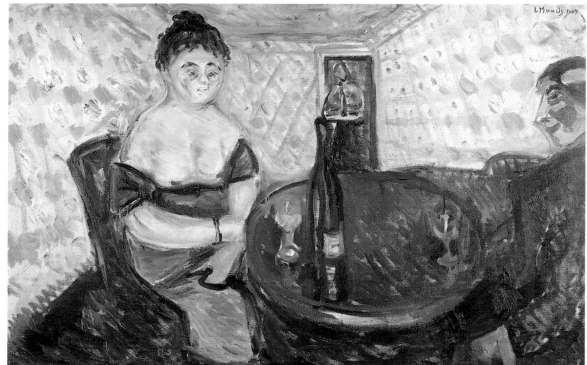

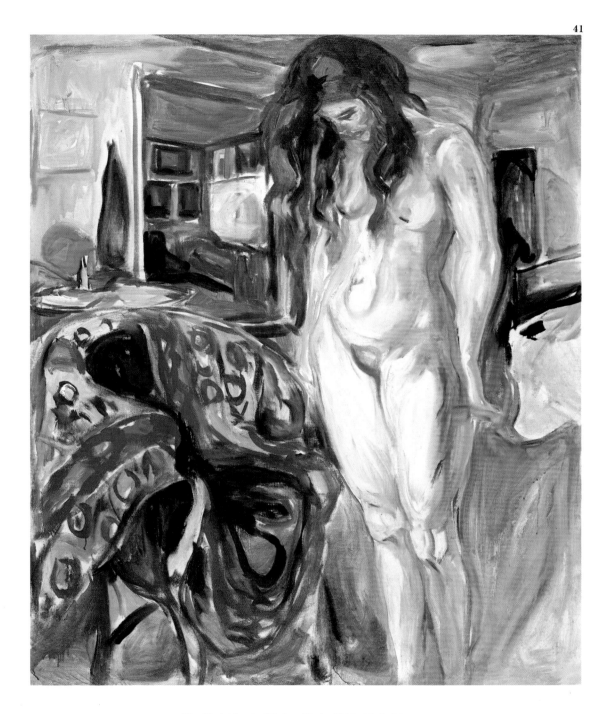

41 Model by the Wicker Chair, *1919–21. In his fifties when he painted this picture, Munch offered once again his own lurid view of feminine sensuality. Here, as in other late works, confined spaces teem with objects, at the same time that they open to reveal other rooms.*

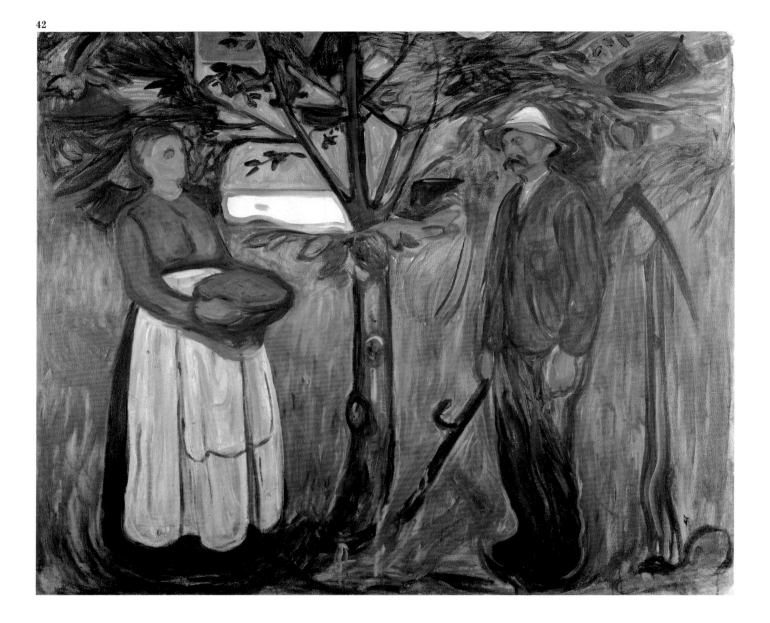

The Vigor of Life

Around 1900, Munch's outlook brightened and his vitality increased. Light and air entered his paintings, lifting the sense of stifling oppression. In many such paintings, men in groups are shown moving purposefully about out-of-doors, divested of all the problematic weight that the relation between the sexes implied for the artist. Concurrently, Munch began to develop new motifs selected from the world of work. Munch had a profound respect for the decency of manual labor, much as Van Gogh had admired the hardworking lives of the potato farmers and the weavers he painted in the mid-1880s. And the Norwegian painter did sympathize with several socialist ideas. But, rather than from a clearly defined political conscience, such works arose from his deep-seated loathing for the smugness of the bourgeoisie, as well as from a complex man's regret at having forgone the opportunity to live a laborer's or a peasant's simple and solitary life, devoid of contradictions.

42 Fertility II, *1902. Occasionally, in his pictures set out-of-doors, Munch's figures seem to breathe and open up to life, and at the same time they shed most of their ambiguity. This painting sings the praise of human labor and of the fruitfulness of nature, whose traditional symbol, the tree, serves here as compositional axis.*

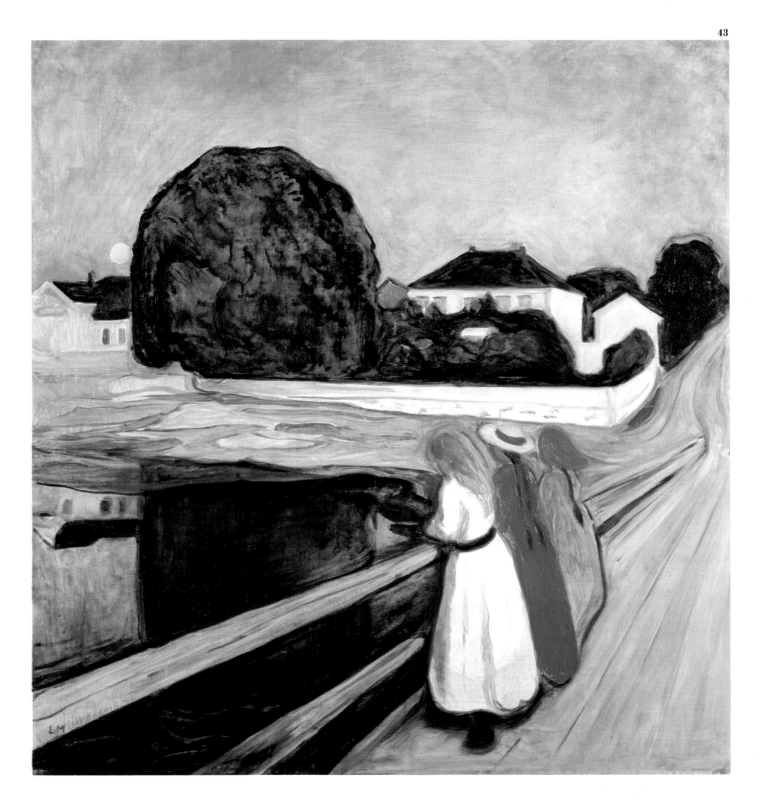

43 Girls on the Jetty, *1901. Munch created eighteen different versions of this painting, as well as a substantial number of woodcuts on the theme. The colors of the girls' dresses are vibrant, and the summer moon is warm—the artist's approach to the theme of youth is here devoid of any negative connotation.*

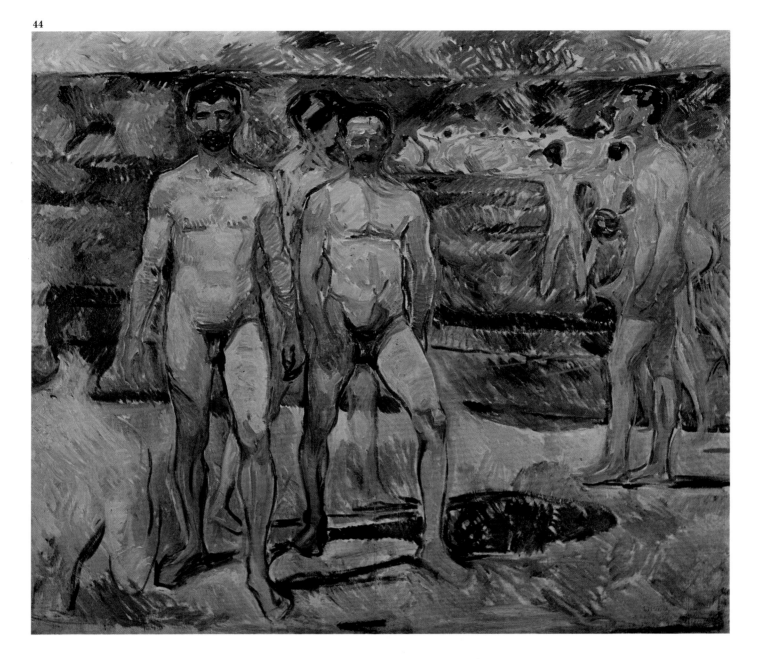

44 Male Bathers, *1907. The illusion of movement in this painting is created by means of a vibrant pattern of short brushstrokes—which visually transform the canvas into a sort of textile.*

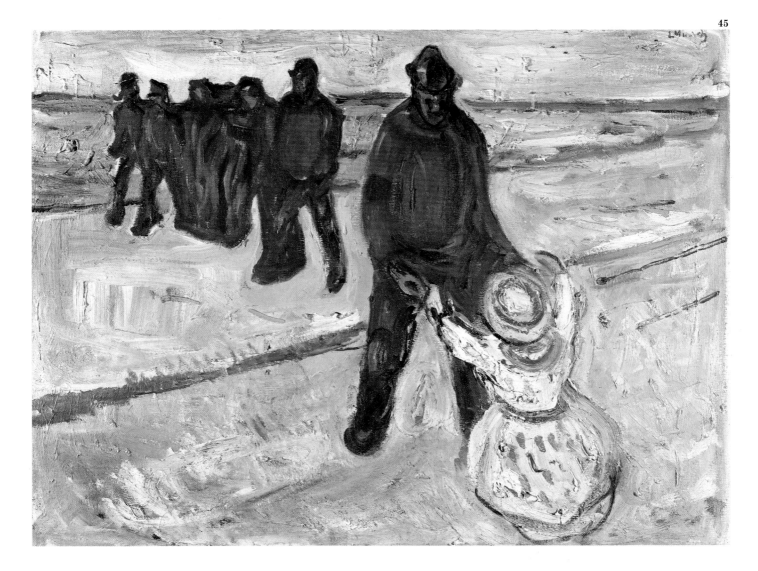

45 Worker and Girl, *1908. Throughout his life,
Munch studied the contrast between people of
different ages. In this painting, a sober procession of
homeward-bound workers—whose dark clothes
express the hardship of their lives—is contrasted
with, and perhaps given meaning by, the joyful
figure of a little girl.*

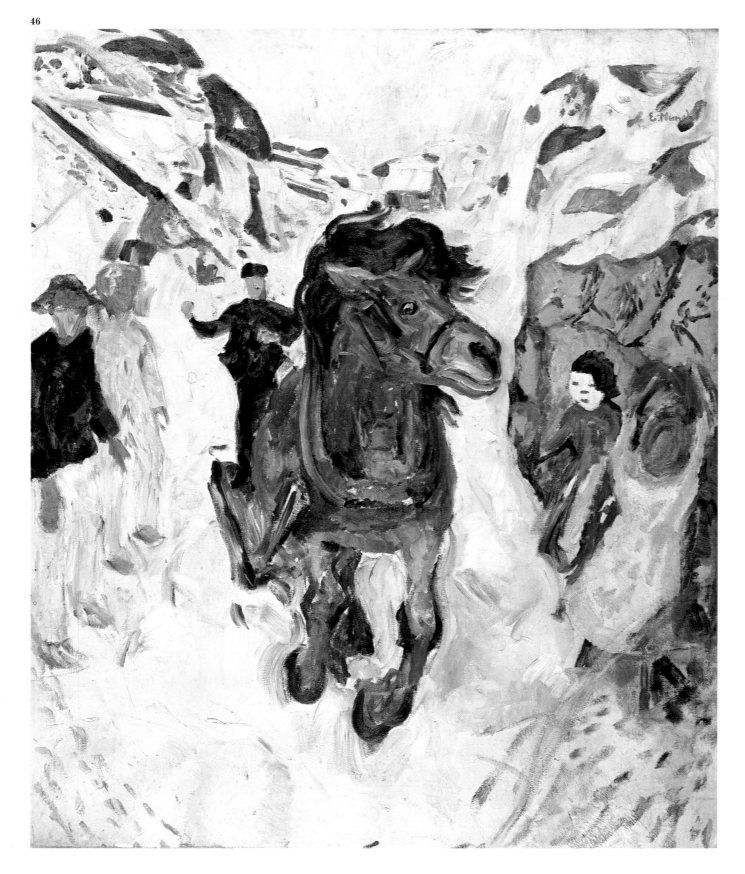

46 Galloping Horse. *1910–12. Throughout his career, Munch used perspective as an expressive tool. In this painting, the extreme foreshortening of the horse, which seems to bear down upon the viewer trapped in a narrow road, makes this a disturbing picture. In many of Munch's works, one senses that the artist must have suffered from both claustrophobia and agoraphobia—fear of closed and open spaces.*

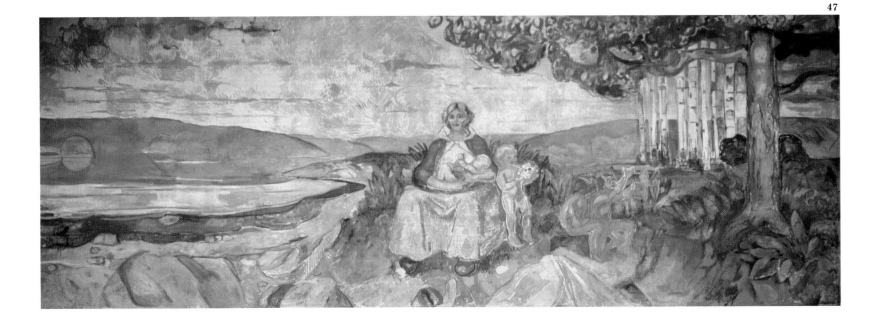

47, 48 Alma Mater, *1911–16*; History, *1911–16. These two large oil paintings are part of the decoration of the main lecture hall of the University of Oslo. Munch, who devoted seven years to the realization of the entire decorative complex, linked these paintings to his earlier cycle the "Frieze of Life." While the latter, in Munch's words, "represents the pains and joys of personal life with a certain immediacy, the decorations of the lecture hall illustrate the great and eternal life forces in the widest sense."*

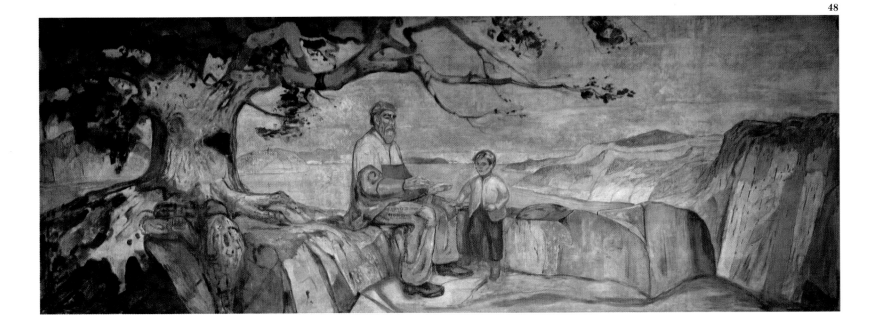

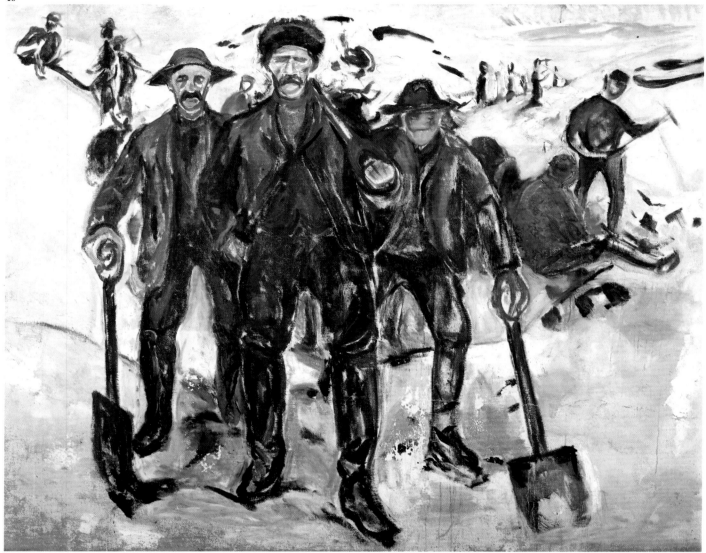

49, 50 Workers in the Snow, *1913*; Workers Returning Home, *1913–15. These paintings offer two rather different visions of labor, and it is interesting to compare them with plates 44 and 45. At left, a party of snow-shovelers give an impression of energy and control over what they are doing, much like the bathers in plate 44. In the painting at right, the workers do not carry the tools of their trade, and they move in a dark stream from the workplace—a factory, perhaps. Like the men in plate 45, they seem to have lost some of their individuality in the course of their day's work.*

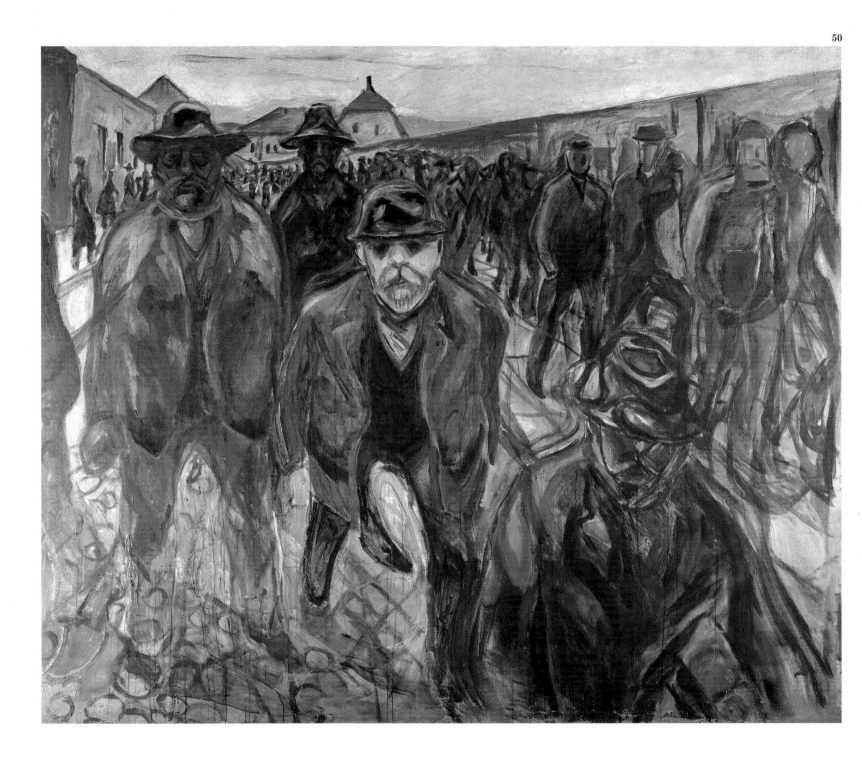

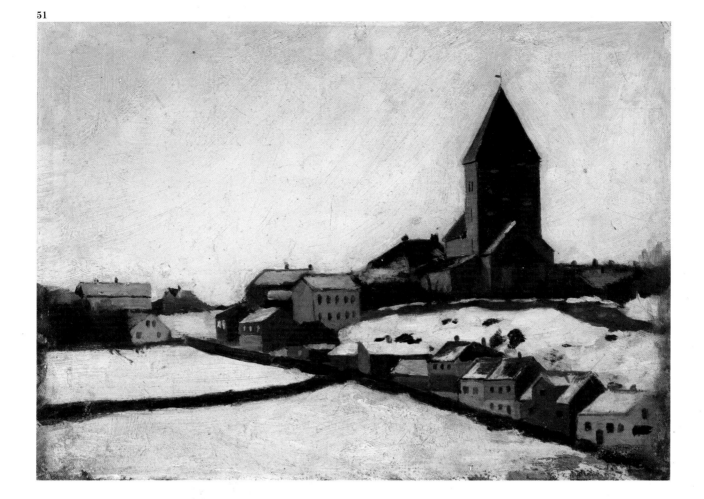

The Expressive Landscape

Though most of Munch's pictures are inward-looking—set indoors or in the landscape of the psyche—he also produced a substantial number of true landscapes of extraordinarily high quality. While his earliest essays in this genre reflect the influence of Impressionism, he soon realized that his personal notion of art was thoroughly alien to the almost scientific detachment with which the Impressionists were attempting to capture nature. Thereafter, landscapes became for Munch a vehicle for his emotions, and in this regard the artist carried on a typically Romantic tradition. Nonetheless, Munch always exhibited a deep commitment to the physical reality of nature. Even in those pictures where the natural environment reflects the emotions of the figures, for example, in *The Scream* and *Angst* (plates 11 and 12), the components of the scenery—sky, water, boats, and buildings—are still identifiable. Clearly, they issued from direct observation, filtered through a human consciousness and sensibility.

51 The Old Church at Aker, *1881. Munch executed detailed versions of this quiet landscape seen in different seasons of the year. The ocher and creamy tones of this winter view suggest that Camille Corot's works may have had some influence on the Norwegian artist.*

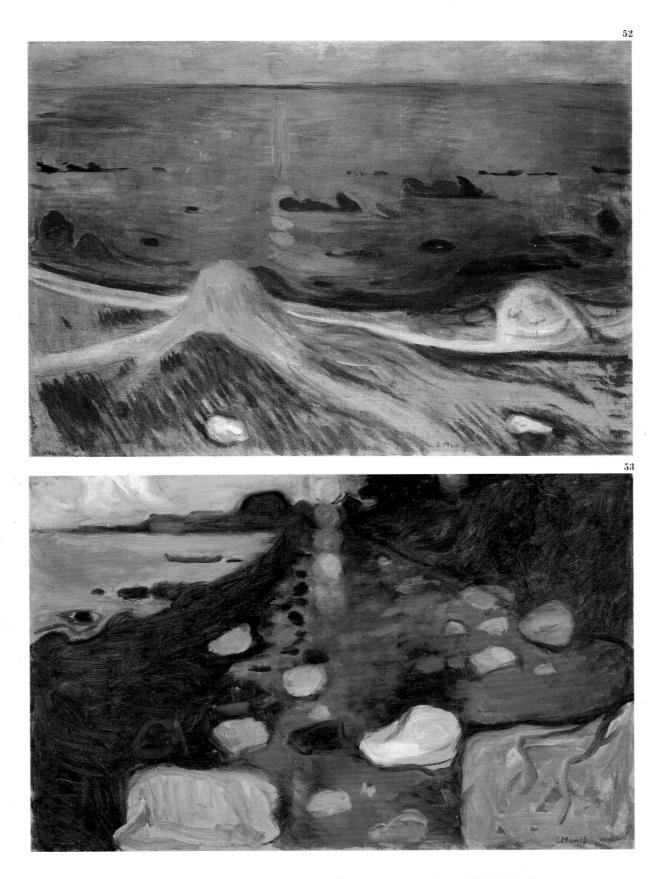

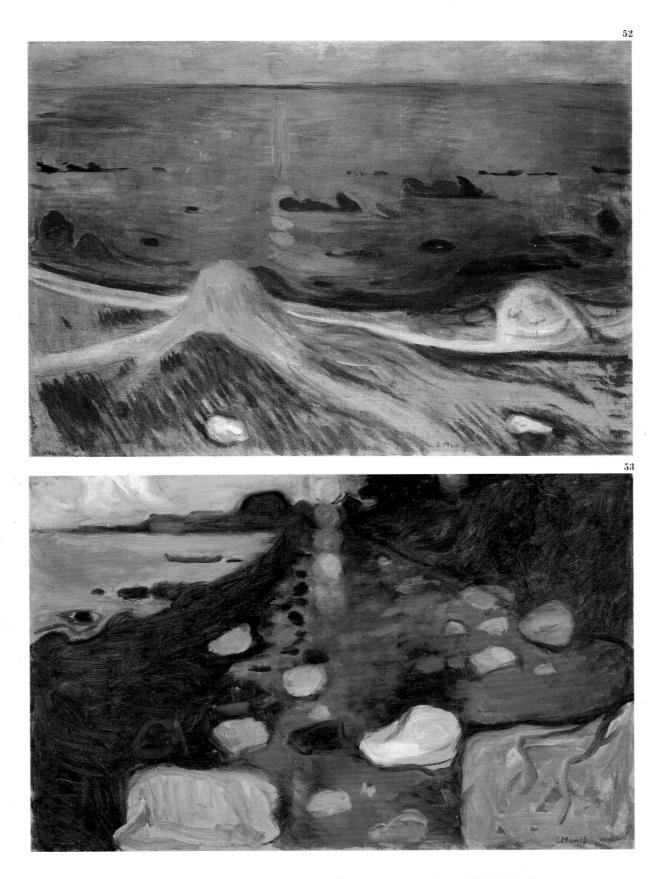

52, 53 The Mystery of a Summer Night, *1892*; Moonlight on the Shore. *1892. Unlike the French Impressionist views Munch had studied and imitated in the 1880s, these two landscapes are endowed with a powerful symbolic quality. They appear to echo a personal experience that the painter described as follows: "It was at dusk, and I was walking by the sea. The moon was shining among the clouds; the rocks against the watery background looked like mysterious inhabitants of the sea, with their large white heads . . . and laughing, some on the beach, others underwater. . . . I could hear the water sigh and whisper around the rocks. Elongated gray clouds over the horizon. Everything seems dead: an otherworldly landscape of death."*

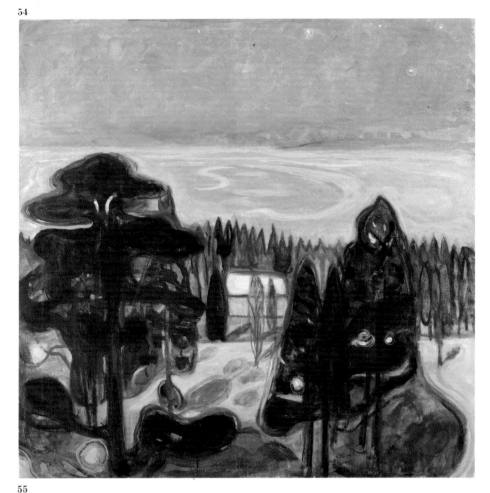

54

55

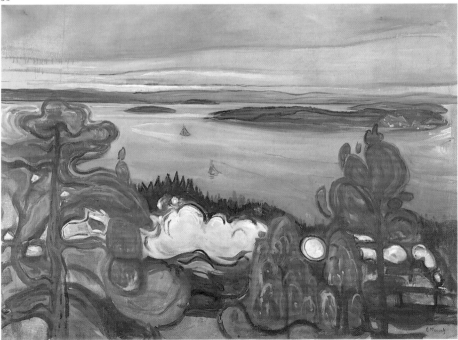

54 White Night, *1901. This view of trees looming against a starry sky cannot fail to evoke Van Gogh's nocturnes. Munch, however, has handled the gamut of blue hues with the utmost delicacy, creating an impression of stillness—rather than of celestial turmoil, as in the night scenes of the Dutch painter.*

55 Train Smoke, *1900. Before he turned to an expressionist style at the beginning of the new century, Munch developed in his landscapes a very beautiful and accomplished interpretation of the sinuous Art Nouveau style.*

56 The Yellow Trunk, *1911–12. Here again, Munch uses perspective to convey an emotional message. The vigorous foreshortening of the shocking-yellow tree trunk carries the viewer's gaze rapidly from the foreground to the back of the scene. The effect is disturbing, in that the viewer feels helplessly pulled along by an uncontrollable force.*

57 Forest, *1903. This small landscape influenced the group of painters who in 1905 formed an association known as Die Brücke. The violent brushwork and the arbitrary use of color that would characterize the work of these early German Expressionists are already present in* Forest.

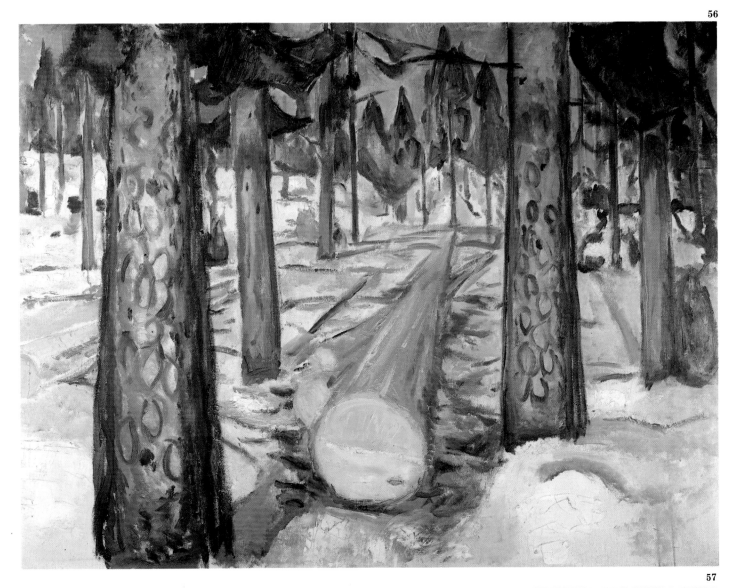

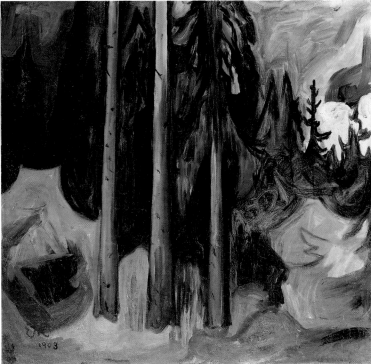

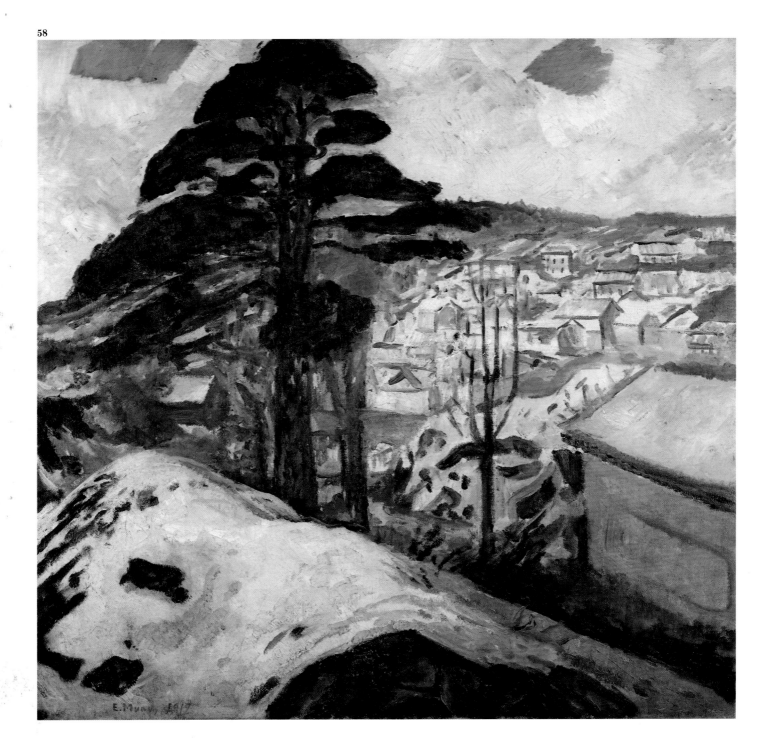

58 Winter in Kragerø, *1912. After his release from a Danish psychiatric institution in 1909, Munch returned to Norway and lived off and on until 1916 in the town represented here. The landscapes that he painted during this period are pervaded by a renewed sense of optimism and seem devoid of symbolism.*

59, 60 Red Stable and Firs, *c. 1927;* Springtime Landscape with Red House, *c. 1935. In the landscapes that Munch painted in Ekely, Norway—where he resided from 1916 until the end of his life—red buildings often contrast with the whiteness of winter or with the incipient greenness of early spring. The thick, heavy paints of the artist's earlier production made way for colors diluted with turpentine that confer on his work the typical lightness of watercolors.*

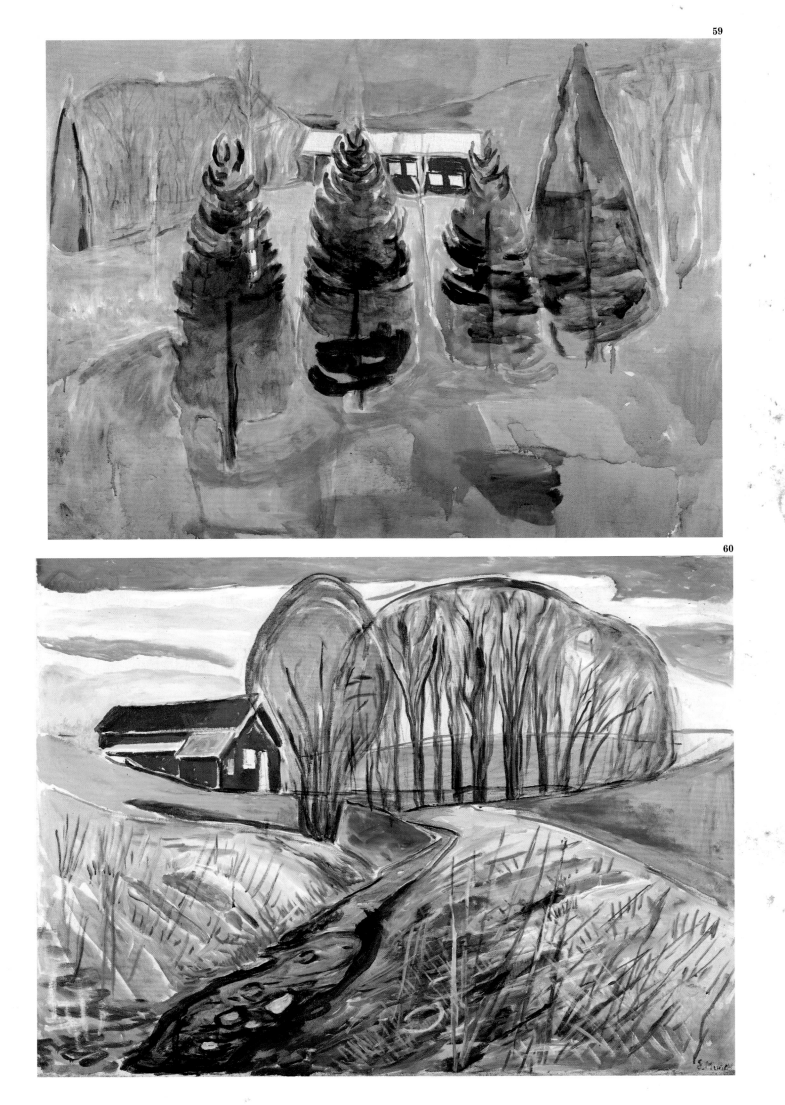

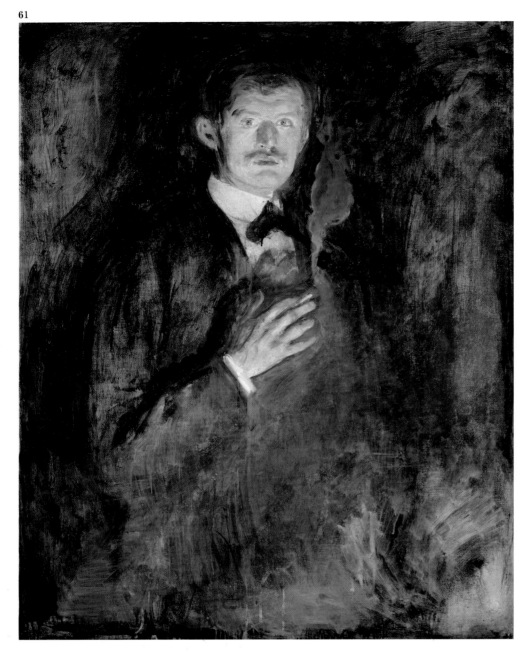

An Honest Look: The Portraits

During his long life, Munch realized a wealth of portraits and self-portraits. In the former (sometimes commissioned, at other times created in recognition of a friendly relationship), the painter is constantly preoccupied with conveying the model's fundamental psychological traits. This endeavor—which in some cases resulted in the client's rejection of the work—transcends the mere representation of the sitter's features and extends in the form of concentric waves through the space occupied by the model. It is, however, with his self-portraits that Munch, free of all external constraints, attained his greater achievements in this genre. The images that the artist painted of himself constitute a record of the effects that time and solitude wrought on his person. There is not a hint of self-complacency in these pictures: most of the time, they show a human being plunged in sickness and desperation. It was a necessary exercise in sincerity for a painter who regarded the work of art above all as a tool of self-knowledge.

61 Self-Portrait with Cigarette, *1895. This work may have had two prototypes: a photographic portrait of the Swedish playwright August Strindberg and a canvas by a contemporary Norwegian painter, Christian Krohg. Munch, who had a theatrical desire to seem mysterious, must have particularly liked the idea of using smoke as a means to dissolve the figure.*

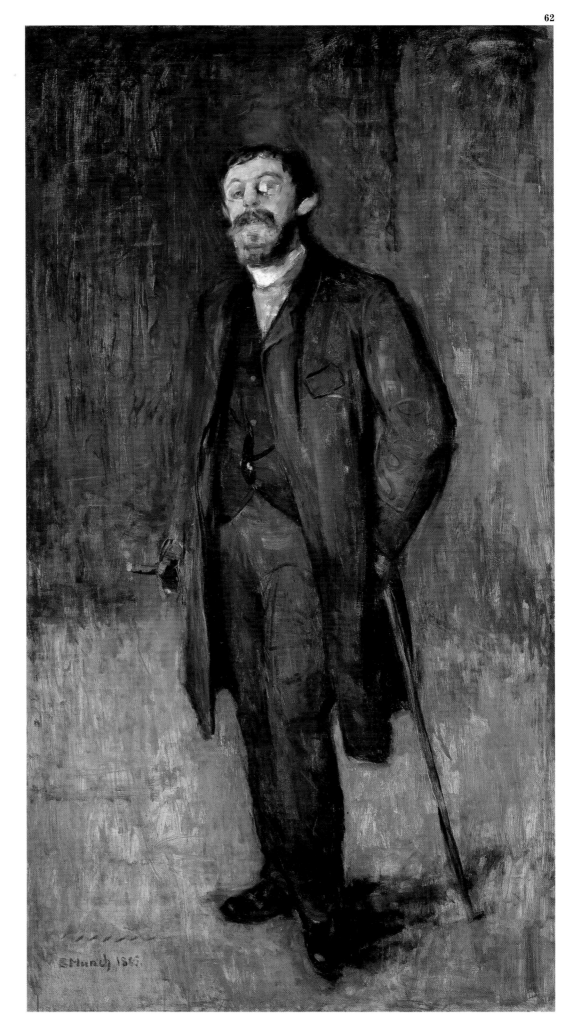

62 The Painter Jensen-Hjell, *1885. The influence of Édouard Manet on the young Munch is evident in this picture of his friend and colleague Karl Jensen-Hjell, whom he portrayed in a somewhat insolent pose. When this work was presented at the Fall Salon in the Norwegian capital, it stirred a monumental scandal.*

63

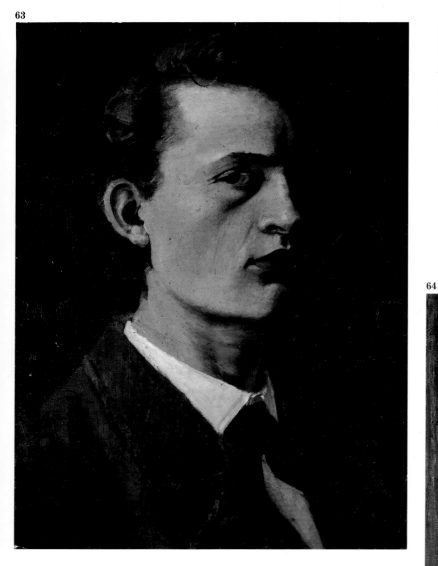

64

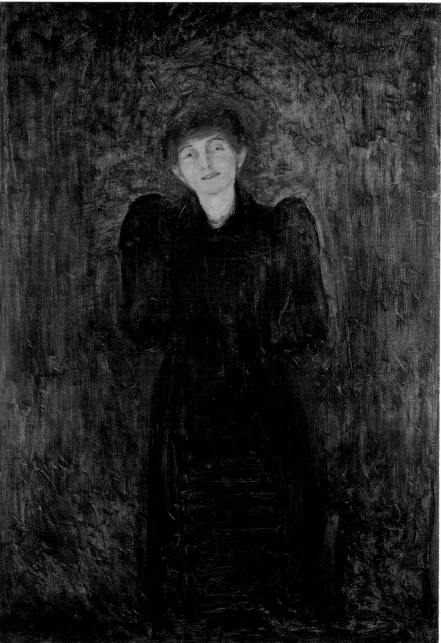

64 Dagny Juell Przybyszewska, *1893. In 1893, when Munch introduced his childhood friend Dagny Juell to the group of bohemians with whom he was friendly, he could not have foreseen the devastating effect that her freethinking sexual attitudes would have on them. Within a few months, the confraternity dispersed: all of its members scattered in different directions, except for the poet Stanislaw Przybyszewski, whom she eventually married.*

65 Walther Rathenau, *1907. During visits to Germany at the beginning of his career, Munch painted a series of large-format full-figure portraits. Though he never resorted to flattery, the painter's portrayal of his clients is invariably deferential. The subject of this portrait was a wealthy industrialist—a chief officer of the Allgemeine Elektrizitäts-Gesellschaft (AEG)— who would later become minister of foreign affairs.*

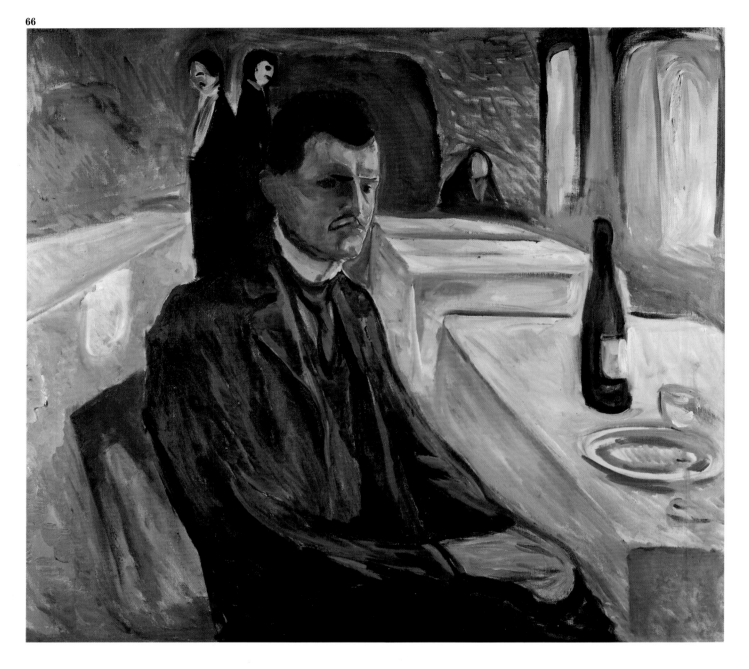

66 Self-Portrait with Wine Bottle, *1906. In this extremely honest self-portrait, Munch depicted himself as a forlorn man, plunged in a severe state of depression. The rapidly receding sides of the tables and the bottle—which was partially the cause of the painter's troubles—forcibly direct the viewer's attention to the back of the room, where sits an enigmatic and solitary figure who may represent death.*

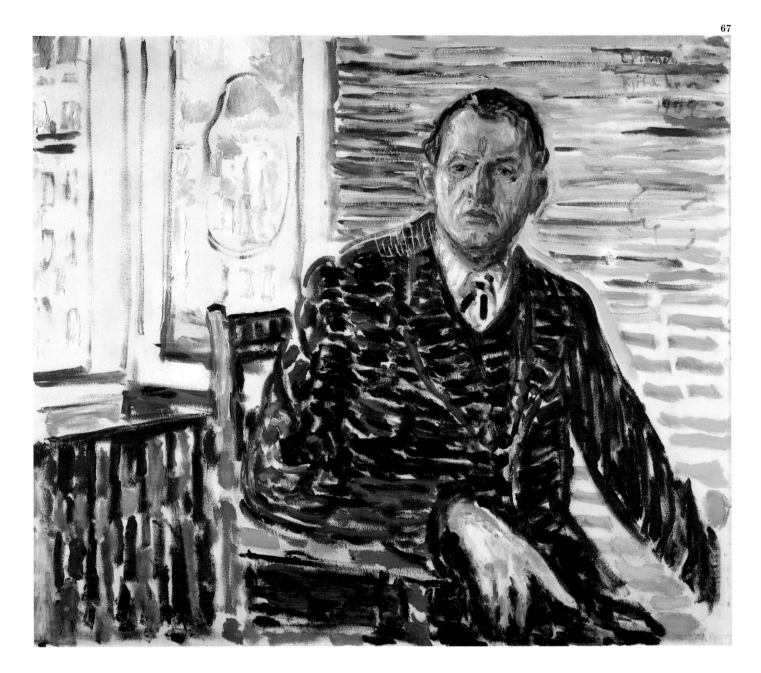

67 Self-Portrait at Clinic, *1909. Munch painted this work during his convalescence in a psychiatric institution. The painter's desire to focus on psychological aspects is attested by the detailed rendering of the face and the sketchy quality of the setting.*

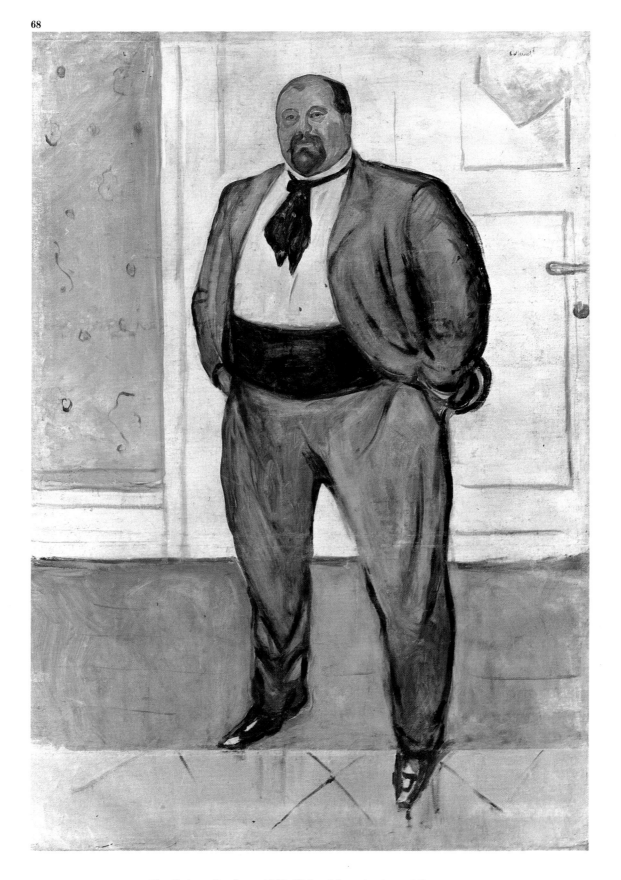

68 Christen Sandberg, *1909. With subtle and not so subtle means,*
Munch conveys the social success of the subject. A wealthy member
of Norway's upper class, Sandberg is shown stepping aggressively
out into the space that separates us from him, flaunting his bulk.
Even the position of the door handle emphasizes his importance.

69 Christian Gierløff, *1910.
When portraying his own
friends, Munch appears more
at ease than when
undertaking a purely
professional commission.
Here, with loose brushstrokes
and a vibrant palette, he
reveals his sympathy for the
sitter, whose evidently
buoyant personality is
conveyed by the gentle waves
that surround his figure.*

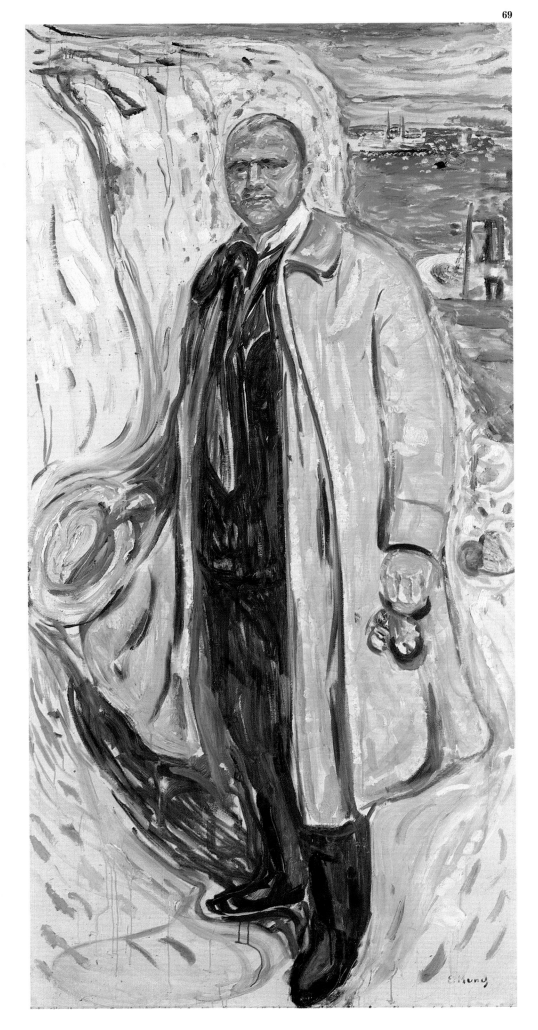

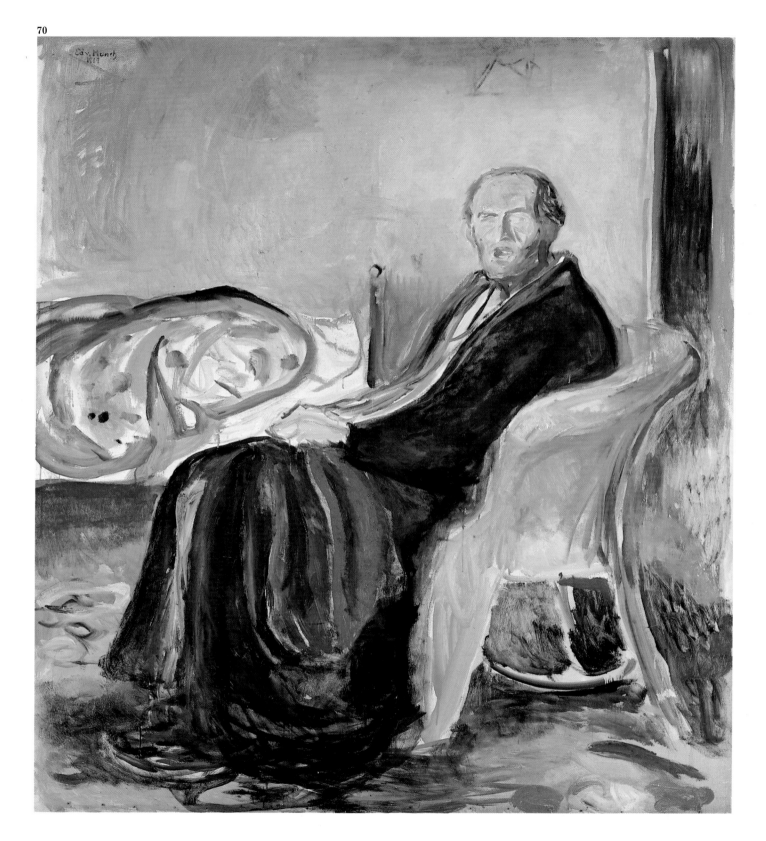

70 Self-Portrait after the Flu, *1919. In the last decades of his life, Munch painted a substantial number of self-portraits that reveal the signs of his physical decay. Here, though clearly wasted by illness, the painter's spirit seems vibrant, conveyed by the brilliance of the colors that burn around him.*

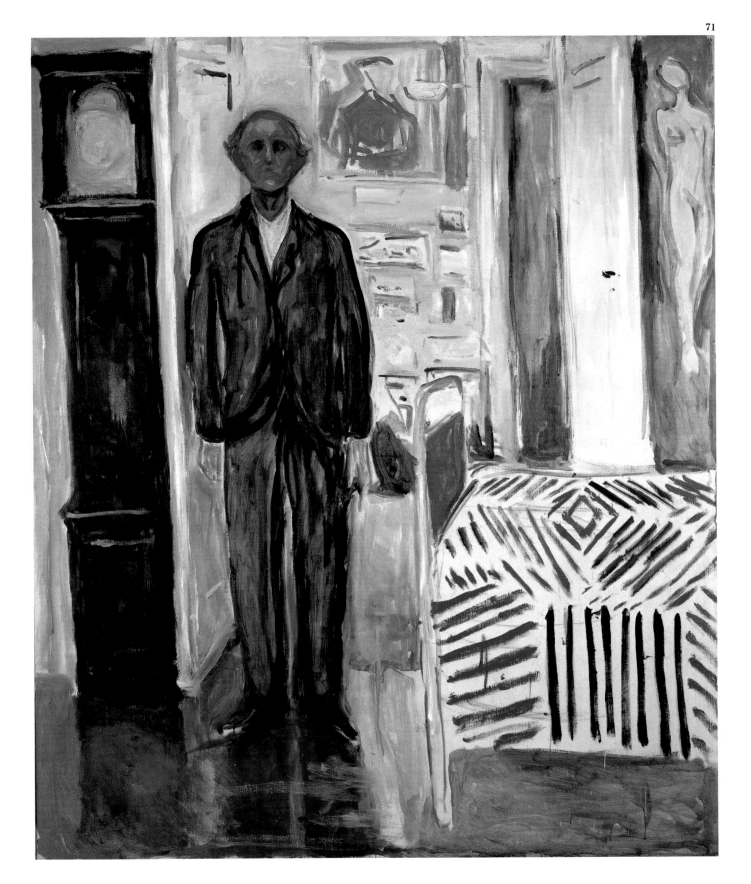

71 Self-Portrait between the Clock and the Bed, *1940–42. With his eightieth birthday drawing near, Munch painted this last self-portrait with a keen awareness of his own impending end. He shows us an exceedingly frail old man posing between a clock and his own bed—symbols of the passing of time, on the one hand, and of weakness or illness, on the other. In contrast with the brightness of the room behind the subject, a narrow door in the far wall ominously opens on darkness, foreshadowing the artist's approaching death.*

List of Plates

1 Landscape: Maridalen near Oslo, *1881. Oil on panel, 8⅝ × 10³⁄₁₆″ (22 × 27.5 cm). Munch-museet, Oslo*

2 Sitting at the Tea Table, *1883. Oil on canvas, 17⅞ × 30½″ (45.5 × 77.5 cm). Munch-museet, Oslo*

3 Girl Kindling the Stove, *1883. Oil on canvas, 37⅜ × 26″ (95.5 × 66 cm). Private collection*

4 Morning, *1884. Oil on canvas, 38 × 40¾″ (96.5 × 103.5 cm). Collection Rasmus Meyer, Bergen*

5 The Sick Child, *1885–86. Oil on canvas, 47 × 46⅝″ (119.5 × 118.5 cm). Nasjonalgalleriet, Oslo*

6 Spring, *1889. Oil on canvas, 66½ × 103¾″ (169 × 263.5 cm). Nasjonalgalleriet, Oslo*

7 Hans Jaeger, *1889. Oil on canvas, 43⅛ × 33⅛″ (109.5 × 84 cm). Nasjonalgalleriet, Oslo*

8 Spring Day on Karl Johan Street, *1890. Oil on canvas, 31½ × 39⅜″ (80 × 100 cm). Bergen Billedgalleri*

9 Night in Saint-Cloud, *1890. Oil on canvas, 25⅜ × 21¼″ (64.5 × 54 cm). Nasjonalgalleriet, Oslo*

10 Evening on Karl Johan Street, *1892. Oil on canvas, 33¼ × 47⅝″ (84.5 × 121 cm). Collection Rasmus Meyer, Bergen*

11 The Scream, *1893. Oil, casein, and pastel on cardboard, 35⅞ × 28⅞″ (91 × 73.5 cm). Nasjonalgalleriet, Oslo*

12 Angst, *1894. Oil on canvas, 37 × 28¾″ (94 × 73 cm). Munch-museet, Oslo*

13 Puberty, *1894. Oil on canvas, 59⅝ × 43¼″ (151.5 × 110 cm). Nasjonalgalleriet, Oslo*

14 Death in the Sickroom, *1894–95. Oil on canvas, 59 × 66″ (150 × 167.5 cm). Nasjonalgalleriet, Oslo*

15 The Dead Mother and the Child, *1897–99. Tempera on canvas, 41⅛ × 70⅝″ (104.5 × 179.5 cm). Munch-museet, Oslo*

16 Golgotha, *1900. Oil on canvas, 31½ × 47¼″ (80 × 120 cm). Munch-museet, Oslo*

17 The Murderer, *1910. Oil on canvas, 37¼ × 60⅝″ (94.5 × 154 cm). Munch-museet, Oslo*

18 At the Deathbed (Fever), *c. 1915. Oil on canvas, 73⅝ × 92⅛″ (187 × 234 cm). Munch-museet, Oslo*

19 The Red Vine, *1898–1900. Oil on canvas, 47 × 47⅝″ (119.5 × 121 cm). Munch-museet, Oslo*

20 Melancholy (Jappe at the Beach), *1892–93. Oil on canvas, 28⅜ × 38⅝″ (72 × 98 cm). Nasjonalgalleriet, Oslo*

21 Separation, *1894. Oil on canvas, 45¼ × 59⅛″ (115 × 150 cm). Munch-museet, Oslo*

22 Ashes, *1894. Oil and tempera on canvas, 47¼ × 55½″ (120.5 × 141 cm). Nasjonalgalleriet, Oslo*

23 Rose and Amélie, *1893. Oil on canvas, 30¾ × 42⅞″ (78 × 109 cm). Munch-museet, Oslo*

24 Young Man and Prostitute, *1893. Charcoal and gouache, 19⅝ × 18⅞″ (50 × 47.8 cm). Munch-museet, Oslo*

25 The Hands, *1893. Oil on panel, 35⅞ × 30⅜″ (91 × 77 cm). Munch-museet, Oslo*

26 The Voice, *1893. Oil on canvas, 35⅜ × 46⅝″ (90 × 118.5 cm). Munch-museet, Oslo*

27 The Three Stages of Woman, *1894. Oil on canvas, 64⅝ × 98⅜″ (164 × 250 cm). Collection Rasmus Meyer, Bergen*

28 Vampire, *1893–94. Oil on canvas, 35⅞ × 42⅞″ (91 × 109 cm). Munch-museet, Oslo*

29 Eye to Eye, *1894. Oil on canvas, 53½ × 43¼″ (136 × 110 cm). Munch-museet, Oslo*

30 The Day After, *1894–95. Oil on canvas, 45¼ × 59⅞″ (115 × 152 cm). Nasjonalgalleriet, Oslo*

31 Madonna, *1894–95. Oil on canvas, 35⅞ × 27¾″ (91 × 70.5 cm). Nasjonalgalleriet, Oslo*

32 Jealousy, *1895. Oil on canvas, 26⅜ × 39⅜″ (67 × 100 cm). Collection Rasmus Meyer, Bergen*

33 Jealousy I, *1896. Lithograph, 12⅞ × 18⅛″ (32.6 × 46 cm). Munch-museet, Oslo*

34 The Kiss, *1897. Oil on canvas, 39 × 31⅞″ (99 × 81 cm). Munch-museet, Oslo*

35 Metabolism, or The Transformation of Matter, *1899. Oil on canvas, 67⅞ × 55⅞″ (172.5 × 142 cm). Munch-museet, Oslo*

36 The Murderess, *1906. Oil on canvas, 43¼ × 47¼″ (110 × 120 cm). Munch-museet, Oslo*

37 The Dance of Life, *1899–1900. Oil on canvas, 49¼ × 75″ (125.5 × 190.5 cm). Nasjonalgalleriet, Oslo*

38 The Death of Marat, *1907. Oil on canvas, 59 × 78¾″ (150 × 200 cm). Munch-museet, Oslo*

39 Jealousy, *1907. Oil on canvas, 29⅞ × 38⅝″ (76 × 98 cm). Munch-museet, Oslo*

40 At the Whorehouse, *1907. Oil on canvas, 33½ × 51⅜″ (85 × 131 cm). Munch-museet, Oslo*

41 Model by the Wicker Chair, *1919–21. Oil on canvas, 48¼ × 39⅜″ (122.5 × 100 cm). Munch-museet, Oslo*

42 Fertility II, *1902. Oil on canvas, 50⅜ × 59⅞″ (128 × 152 cm). Munch-museet, Oslo*

43 Girls on the Jetty, *1901. Oil on canvas, 53½ × 49⅜″ (136 × 125.5 cm). Nasjonalgalleriet, Oslo*

44 Male Bathers, *1907. Oil on canvas, 81⅛ × 109″ (206 × 277 cm). Athenaeum Art Museum, Helsinki*

45 Worker and Girl, *1908. Oil on canvas, 29⅞ × 35⅜" (76 × 90 cm). Munch-museet, Oslo*

46 Galloping Horse, *1910–12. Oil on canvas, 58¼ × 47" (148 × 119.5 cm). Munch-museet, Oslo*

47 Alma Mater, *1911–16. Mural in the Aula (main lecture hall), University of Oslo. Oil on canvas, 14'11" × 38' (455 × 1160 cm)*

48 History, *1911–16. Mural in the Aula (main lecture hall), University of Oslo. Oil on canvas, 14'9⅛" × 38'2" (450 × 1163 cm)*

49 Workers in the Snow, *1913. Oil on canvas, 64⅛ × 78¾" (163 × 200 cm). Munch-museet, Oslo*

50 Workers Returning Home, *1913–15. Oil on canvas, 79⅛ × 89⅜" (201 × 227 cm). Munch-museet, Oslo*

51 The Old Church at Aker, *1881. Oil on canvas, 6⁵⁄₁₆ × 8¼" (16 × 21 cm). Munch-museet, Oslo*

52 The Mystery of a Summer Night, *1892. Oil on canvas, 34 × 49"(86.5 × 124.5 cm). Private collection*

53 Moonlight on the Shore, *1892. Oil on canvas, 24⅝ × 37¾" (62.5 × 96 cm). Collection Rasmus Meyer, Bergen*

54 White Night, *1901. Oil on canvas, 45½ × 43½" (115.5 × 110.5 cm). Nasjonalgalleriet, Oslo*

55 Train Smoke, *1900. Oil on canvas, 33¼ × 42⅞" (84.5 × 109 cm). Munch-museet, Oslo*

56 The Yellow Trunk, *1911–12. Oil on canvas, 51⅝ × 63" (131 × 160 cm). Munch-museet, Oslo*

57 Forest, *1903. Oil on canvas, 32½ × 32⅛" (82.5 × 81.5 cm). Munch-museet, Oslo*

58 Winter in Kragerø, *1912. Oil on canvas, 51¾ × 51⅝" (131.5 × 131 cm). Munch-museet, Oslo*

59 Red Stable and Firs, *c. 1927. Oil on canvas, 39⅜ × 51⅛" (100 × 130 cm). Munch-museet, Oslo*

60 Springtime Landscape with Red House, *c. 1935. Oil on canvas, 39⅜ × 51⅛" (100 × 130 cm). Munch-museet, Oslo*

61 Self-Portrait with Cigarette, *1895. Oil on canvas, 43½ × 33⅝" (110.5 × 85.5 cm). Nasjonalgalleriet, Oslo*

62 The Painter Jensen-Hjell, *1885. Oil on canvas, 74¾ × 39⅜" (190 × 100 cm). Private collection*

63 Self-Portrait, *1881–82. Oil on panel, 10 × 7¼" (25.5 × 18.5 cm). Munch-museet, Oslo*

64 Dagny Juell Przybyszewska, *1893. Oil on canvas, 58½ × 39⅛" (148.5 × 99.5 cm). Munch-museet, Oslo*

65 Walther Rathenau, *1907. Oil on canvas, 86⅝ × 43¼" (220 × 110 cm). Collection Rasmus Meyer, Bergen*

66 Self-Portrait with Wine Bottle, *1906. Oil on canvas, 43½ × 47⅜" (110.5 × 120.5 cm). Munch-museet, Oslo*

67 Self-Portrait at Clinic, *1909. Oil on canvas, 39⅜ × 43¼" (100 × 110 cm). Collection Rasmus Meyer, Bergen*

68 Christen Sandberg, *1909. Oil on canvas, 84⅝ × 57⅞" (215 × 147 cm). Munch-museet, Oslo*

69 Christian Gierløff, *1910. Oil on canvas, 80¾ × 38⅝" (205 × 98 cm). Göteborg Art Museum*

70 Self-Portrait after the Flu, *1919. Oil on canvas, 59¼ × 51⅝" (150.5 × 131 cm). Nasjonalgalleriet, Oslo*

71 Self-Portrait between the Clock and the Bed, *1940–42. Oil on canvas, 58⅞ × 47¼" (149.5 × 120 cm). Munch-museet, Oslo*

Selected Bibliography

Edvard Munch: Symbols and Images, catalogue of an exhibition at the National Gallery of Art, Washington, D.C., November 1978–February 1979.

Heller, Reinhold. *Munch: His Life and Work.* London: John Murray, 1984.

Lathe, Carla. *Edvard Munch and His Literary Associates*, catalogue of an exhibition at the University of East Anglia, Norwich, June–October, 1979.

Messer, Thomas. *Edvard Munch.* New York: Harry N. Abrams, 1973.

Munch et la France, catalogue of an exhibition at the Musée d'Orsay, Paris, September 1991–January 1992.

Stang, Ragna. *Edvard Munch: The Man and the Artist.* New York: Abbeville Press, 1979.

Timm, Werner. *The Graphic Art of Edvard Munch.* Greenwich, Conn.: New York Graphic Society, 1969.

Series Coordinator, English-language edition: Ellen Rosefsky Cohen
Editor, English-language edition: Ellyn Childs Allison
Designer, English-language edition: Judith Michael

Library of Congress Catalog Card Number: 96–84011
ISBN 0–8109–4694–7

Printed and bound in Spain by La Polígrafa, S.L.
Parets del Vallès (Barcelona)
Dep. Leg.: B.11581–1996